Thomas Hoeffgen
African Arenas

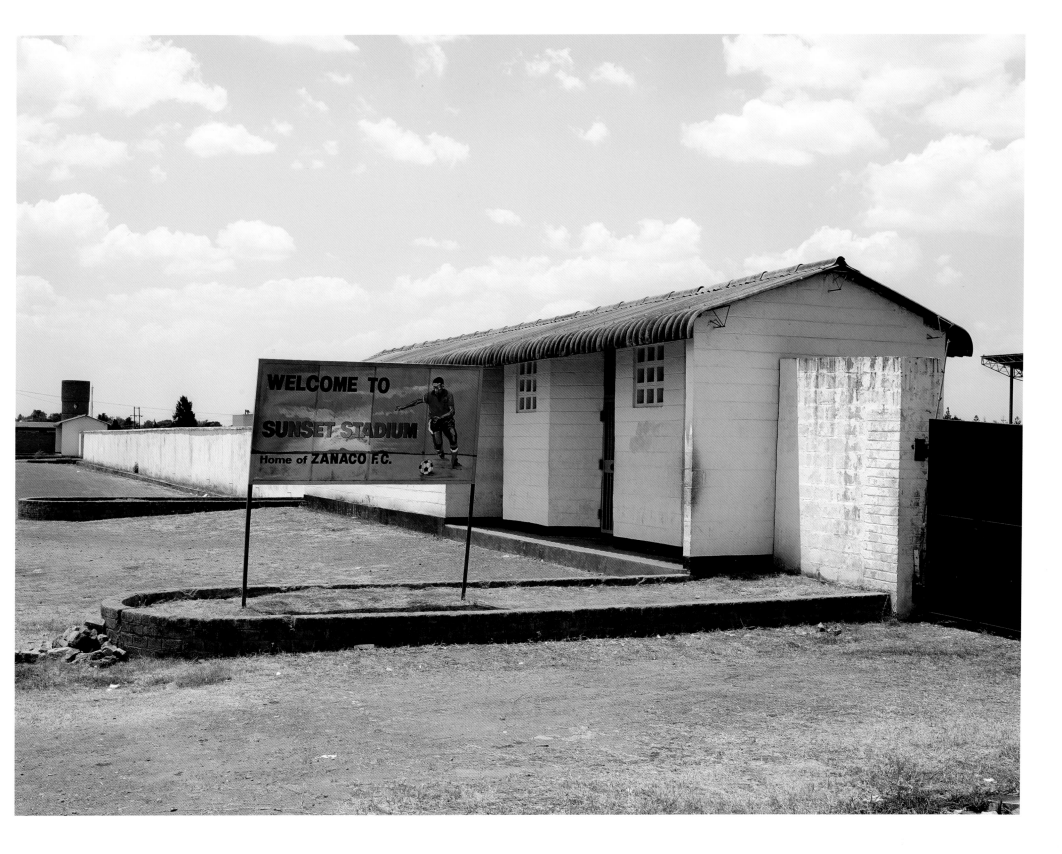

Thomas Hoeffgen
African Arenas

HATJE
CANTZ

Preface
Thomas Hoeffgen

I've always been fascinated by the aesthetics of sports. The first photos I ever took—in 1986, with a manual Pentax given to me by my mother's boyfriend—were of a Formula 1 race at the famous Nuremberg Ring track. Later, as a professional, I did extensive shoots of surfers and snowboarders.

Football, however, was something I came to late. At the Waldorf school I attended as a kid, football was not allowed—we couldn't kick any object that resembled a human head. That delayed my exposure to "the beautiful game," but gave it an added appeal—the appeal of the forbidden.

Then, about a decade ago, *Playboy* magazine asked me to go to Lagos with Jonathan Akpoborie—the Nigerian star then playing in the Bundesliga (German football league) for VfB Stuttgart. The idea was to document the game as Akpoborie had lived it growing up in Nigeria's sprawling former capital.

The Stuttgart forward was unable to make the trip at the last minute and instead arranged for one of his local drivers to show me around the city, taking me to places Akpoborie had played as a youth. On the first day—and I should add that I had been unable to secure a journalist's visa at such short notice—the driver took me to a beautiful sand football pitch. As soon as I climbed out of the car, I noticed a water tower adjacent to the pitch and decided to climb it in order to get a few shots of the field from above.

Fifteen minutes later, two military jeeps screeched to a halt at the base of the tower. My film was confiscated, I was arrested, and—with no proper visa—I was immediately marched over to a nearby police station for questioning. Several hours into the detainment, one of the policemen realized that he and Akpoborie's driver—who had gallantly come to my rescue—were distant relatives. Within five minutes the officer declared himself a huge football fan and I was released—with my film.

During the rest of the trip, I was amazed at the creative use of space in Lagos: In a city crammed with more than nine million residents, football was played on practically every block, with fields shoehorned into even the tiniest open areas. Empty football pitches—with their infinite possibilities—have always had a particular fascination for me. I decided then and there to start shooting empty African pitches and to exhibit them side by side—viewers would be free to imagine their own games on them.

Over the next ten years, I would shoot football pitches in Nigeria, Namibia, Botswana, Zambia, Malawi, and South Africa. And although the focus always remained on the pitches—hence the title *African Arenas*, encompassing everything from sand lots to stadiums built for the 2010 World Cup—my initial concept quickly evolved.

Almost immediately—on that first trip—I realized how important it would be to document the way the game was played on these pitches. I wanted to show the life on and around these makeshift "arenas." The motivation for my change in perspective was simple: almost everywhere I went, the players never showed the slightest interest in what I was doing, instead concentrating on their sport.

I'll never forget coming across a few children playing football beneath a water tower on a stretch of road between Lusaka and Choma, in Zambia. They were playing with a ball stitched together from plastic bags. I stopped the car, got out, and began to assemble my gear. I set up my Contax on a tripod on the roof of the car and began to shoot. None of the kids cast even a glance at me, much less asked me what I was doing. It was clear that here football was all that mattered. And that, after all, is the way it is supposed to be.

Vorwort
Thomas Hoeffgen

Ich habe mich schon immer für die besondere Ästhetik des Sports begeistert. Meine ersten Fotos entstanden 1986 mit einer manuellen Pentax, die mir der Freund meiner Mutter geschenkt hatte – sie zeigen ein Formel-1-Rennen auf dem berühmten Nürburgring. Später, als professioneller Fotograf, schoss ich ganze Serien mit Surfern und Snowboardern.

Den Fußball habe ich erst spät für mich entdeckt. An der Waldorfschule, die ich als Kind besuchte, war Fußball nicht erlaubt – es war gar nicht daran zu denken, nach etwas zu treten, das an einen menschlichen Kopf erinnerte. Das verzögerte meinen Kontakt mit »dem schönen Spiel« zwar, aber verlieh ihm auch einen besonderen Reiz: den Reiz des Verbotenen.

Vor ungefähr zehn Jahren bat mich dann der *Playboy*, mit dem nigerianischen Fußballstar Jonathan Akpoborie, der in der Bundesliga für den VfB Stuttgart spielte, nach Lagos zu reisen. Ich sollte in der ausufernden Metropole das Spiel dokumentieren, so wie es der junge Akpoborie in der ehemaligen Hauptstadt Nigerias erlebt hatte.

In letzter Minute war der Stuttgarter Stürmer leider verhindert und konnte die Reise nicht antreten, er sorgte allerdings dafür, dass mir einer seiner ortskundigen Fahrer die Stadt zeigte und mich zu jenen Orten brachte, an denen Akpoborie in seiner Jugend gespielt hatte. Am ersten Tag – und ich sollte wohl hinzufügen, dass ich so schnell kein Journalistenvisum hatte bekommen können – fuhren wir zu einem großartigen Fußballsandplatz. Als ich aus dem Auto stieg, sah ich einen Wasserturm neben dem Feld und beschloss, von dort oben ein paar Aufnahmen zu machen.

Fünfzehn Minuten später hielten zwei Militärjeeps mit quietschenden Reifen unten am Turm. Mein Film wurde beschlagnahmt, ich wurde verhaftet. Und da ich kein entsprechendes Visum vorweisen konnte, wurde ich unverzüglich zum Verhör in eine nahe gelegene Polizeistation abgeführt. Nach einigen Stunden Haft stellte einer der Polizisten fest, dass er und Akpobories Fahrer – der mir freundlicherweise zu Hilfe geeilt war – entfernte Verwandte waren. Es dauerte nur fünf Minuten, bis sich der Beamte als großer Fußballfan offenbarte und ich auf freien Fuß gesetzt wurde – mit meinem Film.

Die ganze restliche Reise über staunte ich, wie kreativ man in Lagos mit dem Raum umging: In dieser Stadt drängten sich über neun Millionen Einwohner und doch wurde an praktisch jeder Ecke Fußball gespielt, selbst in winzigste Freiflächen wurden noch Spielfelder gezwängt. Leere Spielfelder und deren unerschöpfliche Möglichkeiten haben schon immer eine besondere Faszination auf mich ausgeübt. In jenem Moment beschloss ich, leere afrikanische Fußballplätze zu fotografieren und auszustellen – die Betrachter wären frei, sich dort ihre eigenen Spiele vorzustellen.

In den darauffolgenden zehn Jahren habe ich Plätze in Nigeria, Namibia, Botswana, Sambia, Malawi und Südafrika abgelichtet. Mein ursprüngliches Konzept entwickelte sich rasch weiter, obwohl der Fokus immer auf den Spielflächen lag – daher der Titel *African Arenas,* der von Bolzplätzen bis zu Stadien für die Fußballweltmeisterschaft 2010 alles umfasst.

Sehr schnell – noch während dieser ersten Reise – wurde mir bewusst, wie wichtig es wäre, die besondere Art und Weise zu dokumentieren, wie auf diesen Plätzen gespielt wird. Ich wollte das Leben in und um diese behelfsmäßigen »Arenen« zeigen. Der Grund für meinen Perspektivwechsel war ganz einfach: Fast überall, wo ich hinkam, interessierten sich die Spieler nicht im Geringsten für meine Arbeit, sondern konzentrierten sich vollständig auf ihren Sport.

Ich werde nie die Begegnung mit ein paar Kindern vergessen, die in Sambia auf einer Straße zwischen Lusaka und Choma am Fuße eines Wasserturms Fußball spielten. Sie traten einen aus Plastiktüten zusammengeflickten Ball. Ich hielt an, stieg aus dem Auto und baute meine Ausrüstung auf. Meine Contax fand auf einem Stativ auf dem Wagendach ihren Platz, und ich begann mit den Aufnahmen. Keines der Kinder würdigte mich auch nur eines einzigen Blickes, ganz zu schweigen von der Frage, was ich da eigentlich mache. Fußball war ganz offensichtlich das Einzige, was zählte. Und so soll es ja im Grunde auch sein.

In Praise of the African Arena
Ian Hawkey

Football binds Africa. In a continent where divisions and quarrels sometimes command the rest of the world's attention, football is Africa's common language, a passion shared as eagerly in Cairo as in Congo or Cape Town. More than nine hundred million people live in Africa, so to generalize can be risky, but there are few things as genuinely Pan-African as the love of the greatest game invented.

Football has also been reinvented by Africans. The sport arrived in Africa with colonialism, but here and there it fed into a culture of ball games that had entertained societies as sophisticated as ancient Egypt, where temple paintings show queens and princesses poised ready to kick ornate balls to one another. We also know that peoples as resourceful as the San of what is now Botswana used the fatty hide cut from the neck of hippopotamus to fashion balls with a lively bounce. Some of the same spirit of invention still defines football in Africa, with its difficult terrains and its shortage of urban space. In Africa, audiences respond most warmly to the most daring, most inventive player, the trickster.

Audiences go to Africa's stadiums to express themselves, too. Nowhere do spectators dress so carefully and vividly for the occasion of a football match. In South Africa, fans exquisitely recraft and paint in club colors the protective helmets once worn by men employed in the country's mines. In West Africa, the traditional figure of the mystic is recast as a cheerleader, clad in grass skirt, beads, and cowrie-shells hung around his or her neck, with a leopard-skin headdress and a wide-eyed, round-mouthed mask on his or her face, patrolling the touchline and grandstand. Football crowds in other places where the game has captured the imagination do face make-up and wear replica shirts. In Africa they paint the whole upper body.

A football crowd in Africa has its own sounds: the resonant blasts of a vuvuzela, the long thin cornets whose prototypes were the horns of a kudu antelope; the tubas, trombones, and trumpets made popular at stadiums in West Africa; or the darbouka drums of the Maghreb. "We come from a continent with a long tradition of praise-singing, and we bring that into football," says the Zulu commentator Zama

Masondo. Football across Africa has its own idiom, has drawn up its own shorthand, its nicknames and terms of reference, its own Esperanto. Nigerians do not announce they will be going in their tens of thousands to the Surulere stadium in Lagos to watch the Nigerian national team, they will say instead they are going to watch The Super Eagles. Cameroonians support The Indomitable Lions, Angolans The Sable Antelopes, Burkinabe fans The Stallions, Rwandans The Wasps, Mozambicans The Mambas, Lesothans The Crocodiles, Beninese The Squirrels. Around these emblems are created costumes. Watch the Ivory Coast national team, and in the stadium there are always two or three elaborate headdresses in the style of an elephant. Fabled clubs have formed themselves around beats of the jungle and savannah, like Leopard of Douala, in Cameroon. At the Robert Mensah arena in the city of Cape Coast, Ghana, the derby between Venemous Vipers and Mysterious Dwarves has been the match of the year for well over fifty years.

Africa is good at spectacle. It is also very good at football. At the moneyed end of the world's favorite sport, the wealthy and celebrated clubs of western Europe scour the continent for the teenagers who will one day make up a significant number of the millionaire players in their teams, global icons whose matches are broadcast worldwide, and whose achievements are received back at home as a spur for adolescents to follow. Football has created a significant African diaspora. Watch a game in France's professional league, and perhaps one in three of the players competing will have come from Africa or will be the son of African parents. Watch Barcelona, or Chelsea, or Inter Milan, and in each of those champion sides will be two, three, four, or five African players.

All this recruitment has altered the African stadium. In its audiences may be spotted from time to time a scout, a talent-hunter, usually from Europe. On its pitches at weekends are no longer the very best of Africa's football players, performing in the peak years of their twenties, because those players have usually taken offers to play elsewhere—the very good ones in places like Spain, England, and Italy; the less fortunate in more remote parts of Eastern Europe, where it can be a lonely, alienating new life. The degree to which Africa's brilliance at football is appreciated elsewhere carries dangers. "Now the entire world knows that our sportsmen live in France, how could we dissuade young people they ought to go and seek triumphs there?"

asks the Senegalese writer Fatou Dioumé in her touching novel *The Belly of the Atlantic*. The export of football players out of Africa is an industry, and on its margins unscrupulous business is frequent: parents conned into paying the passage of their sons on a promise of his opportunities as a professional athlete; boys of school age chasing the dream of being the next Eusebio, or George Weah, or Samuel Eto'o then find themselves abandoned in European cities.

But the football stadium has more often been a venue for Africa to display its self-confidence, its might, rather than its vulnerability. It is no coincidence that so many of the continent's larger arenas bear titles like the Independence stadium, or are named after the dates when autonomy from colonial rule or successful revolution were achieved. In nineteen-forties Nigeria, the soon-to-be president Nnamdi Azikiwe helped to pave his country's way to independence from Britain by taking the country's most dashing football club on tour all around that vast nation. After they played, Azikwe would address the crowd: football was his prelude to raising political consciousness, the stadium his parliament. Equally powerful were the displays of the team gathered by the Front de Liberation National at the height of Algeria's war of independence with France. These players volunteered to give up their careers in France to perform under the flag of autonomous Algeria in stadiums across the Maghreb in the nineteen-fifties and sixties. "We were the true precursors of Algerian independence," recalls Mohammed Maouche, the football player who masterminded the plan and spent a year in French prisons for his actions.

In the new millennium, Africa now has some of the finest football arenas, the most architecturally admired, on earth. They have been constructed lavishly in South Africa for the 2010 World Cup, sport's most watched event. Some have grown up on sites, like the edge of Soweto, where once there were simply a pair of makeshift goalposts and boys played barefoot, anticipating the awkward bounce of the ball over bumpy earth, developing their reflexes, and imagining themselves wearing the colors of favored township teams like Kaizer Chiefs or Orlando Pirates. "Football was one of our few joyful releases," Nelson Mandela would recall of the apartheid era in South Africa. There, the football arena became a kind of sanctuary.

Africa's football grounds are, as Mandela put it, places full of joy. "African football," he also said, "is a giant that has been dormant for too long." It is now entering its liveliest phase, ready to show itself off, to share what makes it unique.

Ian Hawkey is a journalist with *The Sunday Times* and the author of *Feet of the Chameleon: The Story of African Football* (2009).

Der Fußball verbindet Afrika. Auf diesem Kontinent, dessen Bild in der übrigen Welt zeitweise nur von Separationsbestrebungen und Unruhen bestimmt wird, ist der Fußball eine gemeinsame Sprache, eine Leidenschaft, die in Kairo genauso geteilt wird wie im Kongo oder in Kapstadt. Da in Afrika über neunhundert Millionen Menschen leben, sollte man vorsichtig mit Verallgemeinerungen sein. Aber es gibt kaum etwas, das so wahrhaft panafrikanisch wäre wie die Liebe zu diesem großartigsten aller Spiele.

Die Afrikaner haben den Fußball neu erfunden. Als Sportart erreichte er Afrika mit der Kolonialisierung, aber hier und da ging er in eine Ballspielkultur ein, die schon so hoch entwickelten Gesellschaften wie dem antiken Ägypten zum Zeitvertreib gedient hatte: Tempelmalereien zeigen Königinnen und Prinzessinnen, bereit, sich reich verzierte Bälle zuzuspielen. Wir wissen auch von erfinderischen Völkern wie den San aus dem heutigen Botswana, die die fetthaltige, vom Hals eines Nilpferds heruntergeschnittene Haut verwendeten, um besonders gut federnde Bälle herzustellen. Etwas von diesem Erfindungsgeist bestimmt den afrikanischen Fußball mit seinen problematischen Bodenverhältnissen und dem knappen Stadtraum noch immer. In Afrika bringt man die größte Begeisterung dem kühnsten, dem einfallsreichsten Spieler entgegen – dem Trickser.

Und das Publikum benutzt Afrikas Stadien, um sich selbst darzustellen. Nirgendwo sonst kleiden sich die Zuschauer so sorgfältig und bunt für ein Fußballspiel. In Südafrika tragen die Fans in Vereinsfarben bemalte Kopfbedeckungen, die den Schutzhelmen der früheren Minenarbeiter nachempfunden sind. In Westafrika erscheint die traditionelle Figur des Sehers als Cheerleader, der im Baströckchen, mit Perlen und Kaurimuscheln um den Hals, einem Schmuck aus Leopardenfell auf dem Kopf und einer Maske mit aufgerissenen Augen und offenem Mund die Seitenlinie und die Haupttribüne abläuft. In anderen fußballbegeisterten Ländern schminken sich die Zuschauer das Gesicht und tragen Vereinstrikots. In Afrika bemalen sie ihren gesamten Oberkörper.

Das afrikanische Stadion hat seine eigenen Geräusche: Man hört den volltönenden Klang einer Vuvuzela – jener langen, dünnen Trompete, die auf die Hörner der Schraubenantilope zurückgeht –, in den Stadien Westafrikas die beliebten Tuben, Posaunen und Trompeten, im Maghreb die Darbukatrommeln. »Auf unserem Kontinent hat der Lobgesang eine lange Tradition, und das bringen wir in den Fußball ein«, meint Kommentator Zama Masondo von den Zulu. In ganz Afrika hat der Fußball eine eigene Sprache, eigene Kürzel, Spitznamen und Bezugssysteme, sein eigenes Esperanto. Nigerianer würden niemals sagen, dass sie zu Zehntausenden ins Surulere-Stadion in Lagos ziehen, um ihre Nationalmannschaft spielen zu sehen, sie sprechen vielmehr davon, sich die Superadler anzuschauen. Kameruner unterstützen die Unbezähmbaren Löwen, Angolaner die Säbelantilopen,

burkinische Fans die Hengste, Ruander die Wespen, Mosambiker die Mambas, Lesothen die Krokodile, Beniner die Eichhörnchen. Um diese Wahrzeichen werden entsprechende Kostüme kreiert. Schauen Sie sich ein Spiel der Nationalmannschaft der Elfenbeinküste an und Sie werden immer auch zwei oder drei Personen im Stadion entdecken, deren aufwendiger Kopfschmuck einem Elefanten nachempfunden wurde. Sagenhafte Clubs wie die Leoparden von Douala in Kamerun haben sich die Tiere des Dschungels und der Savanne zum Vorbild genommen. In der Robert-Mensah-Arena in Cape Coast, Ghana, ist das Derby zwischen den Giftigen Vipern und den Geheimnisvollen Zwergen seit weit über fünfzig Jahren das Fußballereignis des Jahres.

Afrika weiß ein Spektakel zu inszenieren. Es weiß auch, wie man hervorragenden Fußball spielt. Die finanziellen Chancen des beliebtesten Sports der Welt führen dazu, dass die reichen und gefeierten westeuropäischen Clubs den Kontinent nach jenen Teenagern durchsuchen, die eines Tages einen Großteil der millionenschweren Spieler in ihren Teams ausmachen werden – globale Ikonen, deren Turniere weltweit übertragen werden und deren Leistungen den Jugendlichen in ihrer Heimat als Ansporn dienen. Der Fußball hat eine nicht unerhebliche afrikanische Diaspora geschaffen. Nehmen Sie ein beliebiges Spiel der französischen Profiliga, einer von drei Spielern wird aller Wahrscheinlichkeit nach aus Afrika stammen oder afrikanische Eltern haben. Wenn Meister wie Barcelona, Chelsea oder Inter Mailand gegeneinander antreten, wird man auf beiden Seiten zwei, drei, vier oder fünf afrikanische Spieler sehen.

Diese Einkäufe haben das afrikanische Stadion verändert. Unter den Zuschauern finden sich immer wieder Beobachter, Talentsucher, meistens aus Europa. Auf afrikanischen Fußballplätzen treten samstags nicht mehr die besten Spieler des Kontinents in ihren leistungsstarken Zwanzigern an, denn diese Spieler haben in der Regel schon Angebote aus dem Ausland angenommen – die besten gehen nach Spanien, England und Italien, die weniger glücklichen in entlegenere Teile Osteuropas, wo sie unter Umständen ein einsames und entwurzeltes neues Leben erwartet. Die fremde Begeisterung für Afrikas fußballerisches Können birgt Risiken. »Nun, wo die ganze Welt weiß, dass unsere Sportler in Frankreich leben, wie sollten wir junge Leute davon abbringen können, dort den Erfolg zu suchen?«, fragt die senegalesische Autorin Fatou Dioumé in ihrem bewegenden Roman *Der Bauch des Ozeans*. Der Export von afrikanischen Fußballspielern ist ein Geschäft, und zwar eines, das mitunter recht skrupellos sein kann: Eltern werden mit dem möglichen Erfolg ihres Sohnes geködert, damit sie für die Übersiedlung des Profisportlers in spe zahlen; schulpflichtige Jungs jagen dem Traum nach, der nächste Eusebio, George Weah oder Samuel Eto'o zu werden, nur um sich einsam und verlassen in irgendeiner europäischen Stadt wiederzufinden.

Dennoch war die Fußballarena weit häufiger Schauplatz der Stärke und des Selbstvertrauens dieses Kontinents als dessen

Hymne auf das afrikanische Stadion
Ian Hawkey

Verwundbarkeit. Es ist kein Zufall, dass so viele der größeren afrikanischen Austragungsorte Namen tragen wie »Unabhängigkeitsstadion« oder nach Ereignissen benannt wurden, die das Ende der Kolonialherrschaft oder den erfolgreichen Ausgang einer Revolution markieren. In den 1940er-Jahren tourte der spätere Präsident Nnamdi Azikiwe mit dem furiosesten Fußballclub des Landes quer durch Nigeria und ebnete diesem großen Land so den Weg in die Unabhängigkeit von Großbritannien. Im Anschluss an jedes Spiel richtete Azikwe das Wort ans Publikum: Fußball war für ihn der Auftakt, um politisches Bewusstsein zu wecken, das Stadion war sein Parlament. Ebenso wirksam waren die Auftritte der von der Front de Libération National auf dem Höhepunkt des Algerienkriegs zusammengestellten Mannschaft. Diese Spieler gaben freiwillig ihre Profilaufbahn in Frankreich auf, um in den 1950er- und 1960er-Jahren unter der Flagge des autonomen Algeriens die Stadien im ganzen Maghreb zu bespielen. »Wir waren die eigentlichen Wegbereiter der algerischen Unabhängigkeit«, erinnert sich der Spieler Mohammed Maouche. Er war der Kopf hinter dieser Aktion, die ihm ein Jahr in französischen Gefängnissen einbrachte.

Im neuen Jahrtausend nennt Afrika nun einige der schönsten Fußballstadien der Welt sein Eigen – es sind architektonische Meisterleistungen. In Südafrika wurden sie für die Fußballweltmeisterschaft, das global meistbeachtete Sportereignis, besonders großzügig gebaut. Manche wurden an Orten wie dem Rand von Soweto errichtet: dort, wo früher nur provisorische Torpfosten gestanden hatten und Jungen barfuß spielten, den unwägbaren Kurs des Balls auf dem holprigen Untergrund im Blick, wo sie ihre Reflexe trainierten und sich schon in den Farben ihrer Lieblingsteams der Townships sahen, etwa der Kaizer Chiefs oder der Orlando Pirates. »Fußball gehörte zu den wenigen Dingen, die uns Freude und Erleichterung brachten«, erinnerte sich Nelson Mandela später an die Zeit der Apartheid in Südafrika. Dort wurde das Fußballstadion zu einer Art Zufluchtsstätte.

Afrikas Fußballplätze sind, in Mandelas Worten, Orte der Freude. »Der afrikanische Fußball«, so sagte er einmal, »ist ein Riese, der viel zu lange geschlafen hat.« Nun erwacht er zu vollem Leben, bereit, sich stolz zu präsentieren und das mit uns zu teilen, was ihn so einzigartig macht.

Ian Hawkey schreibt als Journalist für *The Sunday Times* **und ist Verfasser von** *Feet of the Chameleon: The Story of African Football* **(2009).**

Arena of Life
Nadine Barth

"Welcome to Sunset Stadium," it says on a painted wooden board, balanced on two thin legs, Beneath this are the words: "Home of Zanaco F. C." The sign features an image of a player in a perfect football uniform, from socks to cleats, smartly kicking a black-and-white leather ball. Between the words "sunset" and "stadium" is a sinking sun, a bright yellow spot, auspicious, almost kitschy, implying that the future might be just beyond the horizon—and that getting there would definitely be worth the effort. The sun on the photograph by Thomas Hoeffgen is still high in the sky, shining on a row of white huts and an iron gate, behind which is obviously the stadium, if such a place can be called a stadium. It is a field, as sandy and parched as the yard in front. A little corner of the stands can be seen, maybe a row of covered seating. We are somewhere in Zambia, and the fact that Zanaco F. C. is in the country's top league and has won the championship five times in the last eight years is totally irrelevant.

It is these symbolic images from the series *African Arenas* that pinpoint the longing, intensity, and love of detail associated with football. Sometimes it consists of nothing more than two wooden posts in the ground, marking a goal, or in a photograph, just a chalk outline on a concrete wall.

The word "arena" comes from the Latin *(h)arena*, which originally meant nothing more than sand. In antiquity, the arena was a sandy spot where people gathered to watch competitions of all sorts: gladiator tournaments, animal fights, running races, and—in larger arenas called "circuses" in Rome—chariot races. Typically, the playing field was set at the lowest point in the center of the area, so that spectators could have a good view of events. This focus on the center, to which all eyes were directed, created an emotionally charged space well-suited to the presentation of ritualistic events. Classical amphitheaters had sand floors, because they soaked up the blood of gladiators or animals. "Bread and circuses" controlled the people and kept them happy. Several centuries later, when Friedrich Schiller devised his theory of "Homo ludens," he referred to the circus mentality of the Romans, although not as the satirical derogation of mass entertainment intended by the poet Juvenal with his phrase "panem et circenses" (whereby "circenses" actually referred to chariot races). Instead, Schiller posited his idea of "playing man" as a counterweight to the dominant

scientific culture of his time. Human beings, according to Schiller, could only develop their abilities to the full through play, and only through play could they experience true freedom of action. In the fifteenth of the *Letters on the Aesthetic Education of Man*, he muses upon the ludic drive, or the urge to play, which he felt should draw only upon the ideal of beauty, because then, man's dual nature—consisting of the sensuous drive whose object is life itself, and the formal drive, concerned with form or "Gestalt"—could unfold and make man whole. "For, to state it plainly once and for all, man only plays when he is human in the full meaning of the word, and he is only fully human when he plays." In the twentieth century, philosopher Herbert Marcuse also railed against the predominance of "instrumental reason" in industrial societies, and declared Homo ludens to be the model of existence worth striving for. Reverting to the aesthetic and the playful would allow people room to do things according to rules of their own choosing.

Now, it is, of course, a long way from the sandy fields of Africa to the conceptual construct of self-determined action. Yet we can be certain that there is hardly a village in Africa that does not have its own football field, even if it is not immediately visible. Goalposts can be set up quickly, a ball made—if necessary, out of plastic bags crunched up and tied together with string—and soon enough, two or three barefoot kids will be seen kicking the makeshift ball around in the dust, until night falls over the playing field. If play is a fundamental human activity that engenders trust and the willingness to cooperate, and, in the heat of competition, also releases energy, vitality, and the will to victory, then the creativity engendered by these temporary playing fields increases the abilities of the players exponentially. Even in the bigger arenas—the stadiums with hundreds or even thousands of seats, where the Africa Cup of Nations takes place, or where the World Cup will be played in 2010—one can sense the earthy, vibrating power that also distinguishes the bare field around the corner.

Thomas Hoeffgen went looking for these sacred sites, and he found them among high-rises, on clearings, behind walls, and in rows, one next to the other, cutting like flight corridors through residential areas. Sometimes he got up very close, stood there on the playing field, photographing a duel over the ball, or a storming of the goal; at other times he took bird's-eye shots, documenting the relation between the town and the field. He was not interested in categorizing African playing fields, or in documenting every single stadium in

Africa. Rather, he wanted to depict the realities of life on a particular continent, and to show the passion manifested in football—a culture of togetherness, which includes everyone and everything. And so they spring up, the weeds and the net-less, red iron goalposts, next to each other, the same height, outlining the boundaries, and looking like figures staring at each other from either end of the field. And even when the field lies deserted in the hot sun, we know that someone will eventually come and play on it.

Hoeffgen employs the style of classic landscape and architectural photography, but he combines it, when necessary, with elements of photojournalism. Hence, the *African Arenas* series is very different from a strongly conceptual work by, say, Hans van der Meer, who decided to photograph amateur league football fields in Europe according to the features of the landscapes that surrounded them (*European Fields: The Landscape of Lower League Football*, 2006). While the Dutch photographer always shows people—amateurs—at play on the fields, Hoeffgen alternates between populated and empty fields, between the medium format and the panorama, between the close-up and the distant shot. He does not select sites based on dramaturgy or democratic principle; he follows his nose to find fields that are somehow charged with a sense of energy, whose beauty and specialness he then captures with his camera. The results are aesthetic views of arenas that are more than simple reflections of the objects themselves. They are the forums for the lives of those who play there. In the bright African sunlight, football shines as an overpowering idea that has long since taken its place among the ranks of global concepts. A game is offered, an audience will experience it; the interaction between the viewer and the field in the photograph begins with the kickoff.

By showing him his playing fields—from the simple field in the middle of nowhere, to the high-tech Soccer City stadium in Johannesburg—Hoeffgen's *African Arenas* depict the fundamental need of Homo ludens to play. For play enables him not only to discover his own abilities but also to understand his whole human existence, and perhaps even to conquer the world as well.

Nadine Barth is a curator and publisher. Through her agency, barthouse culture concepts, she organizes exhibitions of contemporary photography.

Arena des Lebens
Nadine Barth

»Welcome to Sunset Stadium« lautet die Inschrift auf einer bemalten Holztafel, die auf zwei dünnen Stöcken balanciert, darunter steht: »Home of Zanaco F. C.« Das Schild bildet einen Spieler in perfektem Fußballdress ab, mit Stutzen und Stollenschuhen, der schnittig einen schwarz-weißen Lederball tritt. Zwischen den Worten »Sunset« und »Stadium« geht die Sonne unter, ein heller gelber Fleck, verheißungsvoll, kitschig fast, implizierend, dass die Zukunft am Horizont liegen mag, wohin zu streben es sich auf jeden Fall lohne. Die Sonne auf der Fotografie von Thomas Hoeffgen steht noch hoch am Himmel, sie bescheint eine weiße Hüttenreihe und das Eisentor, hinter dem ganz offensichtlich das Stadion liegt, so man es denn ein Stadion nennen mag. Es wird ein Platz sein, so sandig und ausgedörrt wie der Vorplatz, ein Eckchen Tribüne ist zu sehen, vielleicht eine überdachte Sitzreihe. Wir sind irgendwo in Sambia, und dass sich der Club Zanaco F. C. in der ersten Liga seines Landes tummelt und in den letzten acht Jahren fünfmal Meister wurde, tut nichts zur Sache.

Es sind diese symbolträchtigen Bilder, aus denen die Folge *African Arenas* besteht, die Verortung von Sehnsucht, Intensität und Freude in Details, die auf das Fußballspiel hinweisen. Denn manchmal sind es nicht mehr als zwei Holzpflöcke in der Erde, die ein Tor markieren, und auf einem Bild ist es nur ein mit Kreide gezeichneter Umriss auf einer Betonmauer.

Der Begriff »Arena« stammt von dem lateinischen »(h)arena« ab und bedeutet zunächst nichts weiter als »Sand«. In der Antike meinte die Arena einen sandigen Platz innerhalb eines Versammlungsortes, der für Wettkämpfe aller Art genutzt wurde – Gladiatorenkämpfe, Tierkämpfe, auch Wettläufe und in größeren Arenen, bei den Römern »circus« genannt, Wagenrennen. Typisch ist, dass das Spielfeld in der Mitte der niedrigste Punkt ist, damit das Geschehen von jedem Zuschauerplatz verfolgt werden kann. Die Konzentration auf das Zentrum, auf das alle Blicke gerichtet sind, schafft einen mit Emotionen aufgeladenen Handlungsraum, der sich überaus gut zur Ausgestaltung kultischer Darbietung eignet. Im klassischen Amphitheater war der Boden auch deswegen aus Sand, weil er das Blut der Gladiatoren oder Tiere aufsaugen konnte. »Brot und Spiele« – nach der Devise wurde das Volk gezügelt und bei Laune gehalten. Als Friedrich Schiller Jahrhunderte später seine Theorie des »Homo ludens« entwarf, nahm er Bezug auf den circensischen Gedanken der Römer, doch nicht als satirische Abwertung der Massenunterhaltungen, wie es der Dichter Juvenal mit seinem »panem et circenses« gemeint hatte (wobei »circenses« eigentlich Wagenrennen bedeutet), sondern als Gegenprogramm zu der vorherrschenden Wissenschaftskultur. Der

Mensch, so fand Schiller, entwickle über das Spiel erst seine Fähigkeiten und könne wahre Handlungsfreiheit erfahren. Im 15. Brief der Sammlung »Über die ästhetische Erziehung des Menschen« sinniert er über den Spieltrieb, der sich auf das Ideal der Schönheit beziehen solle, und auch nur darauf, denn dann würde seine doppelte Natur, bestehend aus dem sinnlichen Trieb, der als Gegenstand das »Leben« hat, und dem Formtrieb, der sich auf die »Gestalt« bezieht, entfalten können und den Menschen erst vollständig machen: »Denn, um es endlich auf einmal herauszusagen, der Mensch spielt nur, wo er in voller Bedeutung des Worts Mensch ist, und er ist nur da ganz Mensch, wo er spielt.« Auch der Philosoph Herbert Marcuse wetterte im 20. Jahrhundert gegen die Vorherrschaft der »instrumentellen Vernunft« in den Industriegesellschaften und erklärte den Homo ludens zum erstrebenswerten Seinsmodell. In der Rückbesinnung auf das Ästhetische und Spielerische könne ein Freiraum für eine menschliche Betätigung nach selbst gewählten Regeln entstehen.

Nun ist es von den Sandplätzen in Afrika bis zur selbstbestimmten Handlungsfreiheit als gedanklichem Konstrukt natürlich ein weiter Schritt. Aber feststeht, dass es wohl kaum ein Dorf in Afrika gibt, das nicht einen eigenen Bolzplatz hätte, und sei er auch noch so unsichtbar. Ein Tor ist schnell gesteckt, ein Ball geformt – zur Not aus mit Schnüren umwickelten zusammengeknautschten Plastikbeuteln –, und schon sieht man zwei, drei Kids kicken, barfuß im Staub, bis sich die Nacht über den Platz senkt. Wenn das Spiel eine grundlegende menschliche Aktivität ist, die Vertrauen und Kooperationsbereitschaft und im Wettkampf Energie, Vitalität und Siegeswillen freisetzt, so potenziert die Kreativität dieser provisorischen Spielorte die Fähigkeiten der Spieler um ein Vielfaches. Und auch in den größeren Arenen, den Stadien mit Hunderten oder gar Tausenden von Sitzplätzen, in denen der Africa Cup of Nations ausgetragen wird oder 2010 die Weltmeisterschaft, ist etwas von der vibrierenden erdverbundenen Kraft zu spüren, die das nackte Feld um die Ecke auszeichnet.

Thomas Hoeffgen hat sich auf die Suche nach diesen kultischen Stätten gemacht – er findet sie zwischen Hochhäusern und auf Lichtungen, hinter Mauern und als Band mehrerer Plätze, das wie eine Flugschneise Wohnareale durchtrennt. Mal geht er nah heran, steht mit auf dem Spielfeld, hält einen Zweikampf fest oder einen Sturm aufs Tor, mal fotografiert er aus der Vogelperspektive, zeichnet auf, wie sich der Ort und das Feld zueinander verhalten. Es geht ihm nicht um eine Typologie afrikanischer Plätze oder eine möglichst vollständige Dokumentation aller in Afrika befindlichen Stadien. Es geht ihm

um die Darstellung der Lebenswirklichkeit eines Kontinents und einer Leidenschaft, die sich im Fußball manifestiert. Eine Miteinanderkultur, die alle und alles miteinbezieht. Und so ragen sie auf, das Gestrüpp und das rote Eisentor ohne Netz, nebeneinander und gleich groß, bestimmen den einen Spielfeldrand und wirken wie Figuren, deren Blick zum anderen Ende gerichtet ist. Und obwohl der Platz verlassen in der gleißenden Sonne liegt, weiß man, er wird bespielt.

Stilistisch bedient sich Thomas Hoeffgen der Mittel klassischer Landschafts- und Architekturfotografie, aber er mischt sie, wo nötig, mit den Elementen der Reportage. So unterscheiden sich die *African Arenas* von der stark konzeptuellen Arbeit eines Hans van der Meer, der die Fußballplätze der Amateurligen Europas nach den Gesichtspunkten der sie umgebenden Landschaft auswählte (*Spielfeld Europa: Landschaften der Fußball-Amateure*, 2006). Während bei dem Niederländer immer Menschen, Sonntagskicker, zu sehen sind, wechselt Hoeffgen zwischen belebten und unbelebten Feldern, zwischen Mittelformat und Panorama, zwischen Nähe und Distanz. Die Auswahl der Orte folgt keiner inneren Dramaturgie und keinem demokratischem Prinzip, sie erfolgt aus einem Gespür für energetisch aufgeladene Plätze heraus, deren Schönheit und Besonderheit Hoeffgen mit seiner Kamera einfängt. Entstanden sind ästhetische Ansichten von Arenen, die mehr sind als bloße Abbilder ihrer selbst. Sie sind Foren der Lebendigkeit derer, die sie bespielen. Der globale Gedanke des Fußballs scheint in dem hellen afrikanischen Licht zur übermächtigen Idee auf, deren Selbstverständlichkeit längst in den Rängen Platz genommen hat. Ein Spiel wird geboten, ein Zuschauer wird es erleben, die Interaktion des Bildbetrachters mit dem auf der Fotografie dargestellten Platz ist bereits der Anpfiff.

Die *African Arenas* von Thomas Hoeffgen beschreiben das Grundbedürfnis des Homo ludens, indem sie ihm seine Plätze zeigen, vom einfachen Feld im Nirgendwo bis zum Hightech-Stadion »Soccer City« in Johannesburg. Spielerisch kann er seine Fähigkeiten entdecken, spielerisch sein Menschsein begreifen – und spielerisch vielleicht die Welt erobern.

Nadine Barth ist Kuratorin und Herausgeberin. Mit ihrer Agentur barthouse culture concepts organisiert sie Ausstellungen zur zeitgenössischen Fotografie.

Babylon, Namibia, 2007

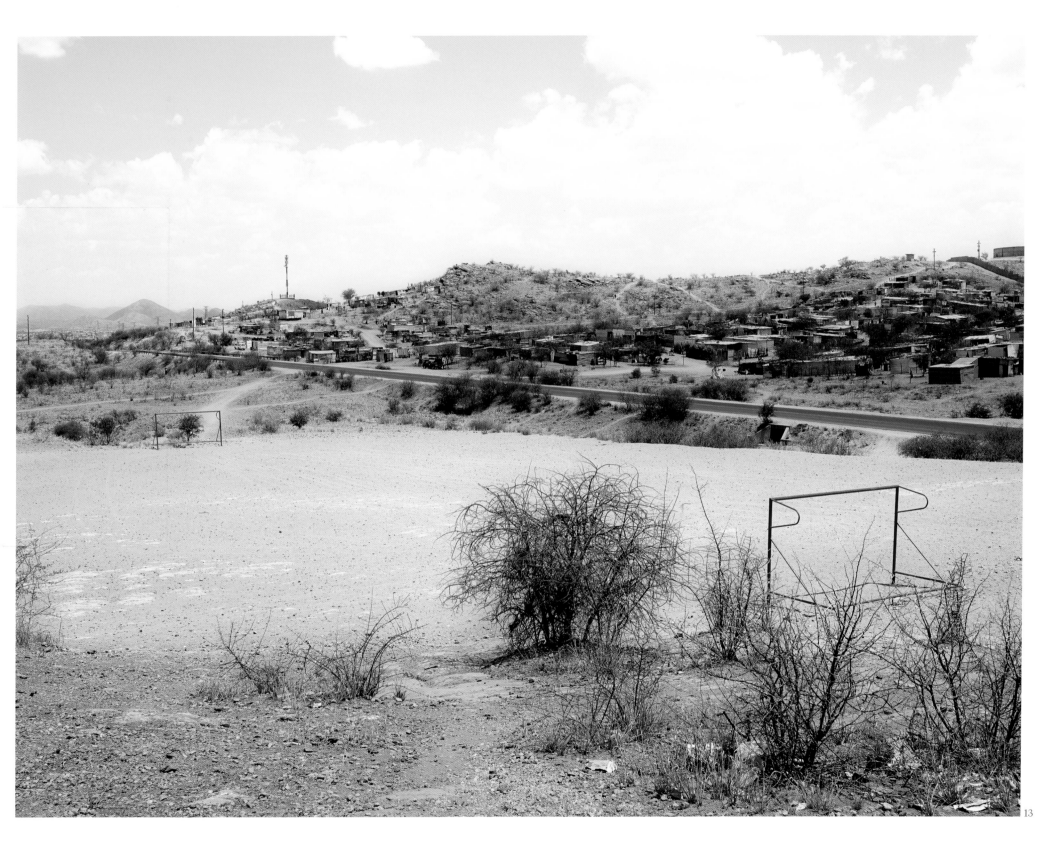

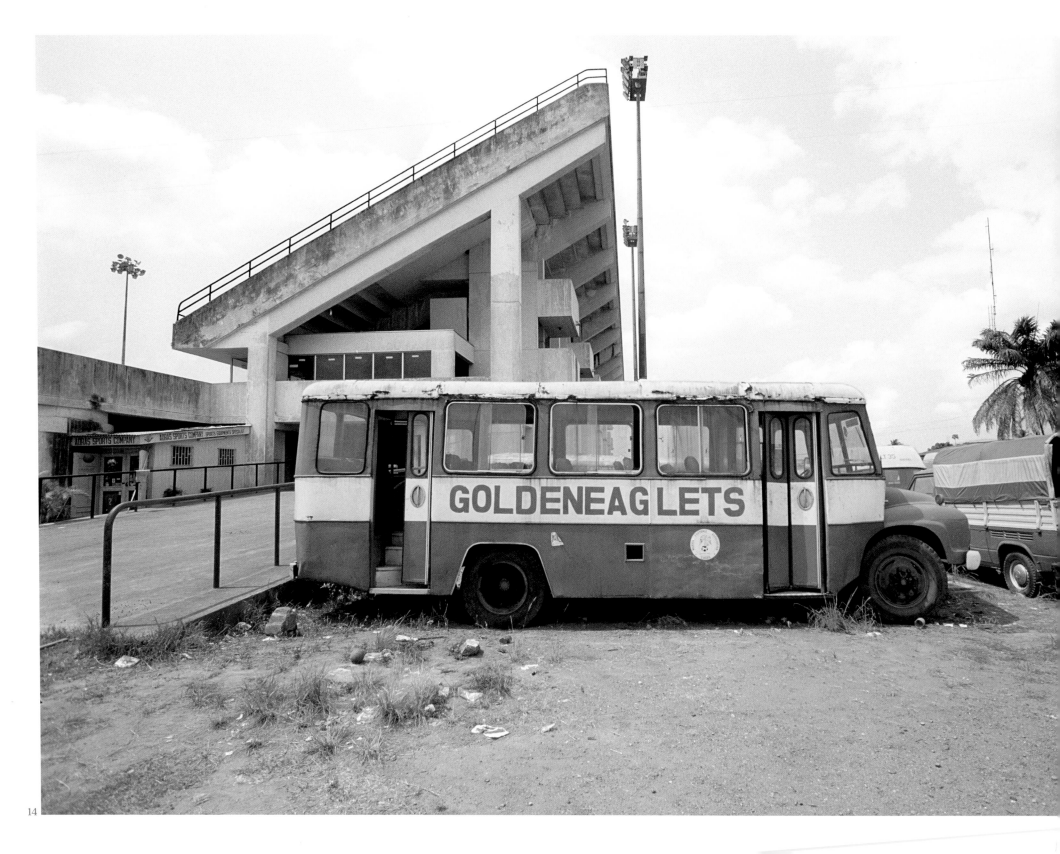

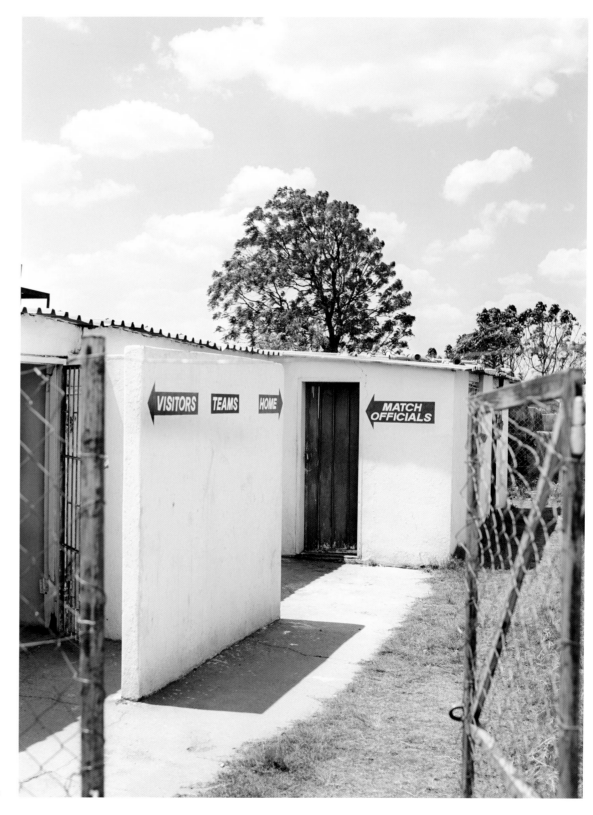

Abuja, Nigeria, 1999 Queensmead Stadium, Lusaka, Zambia, 2007

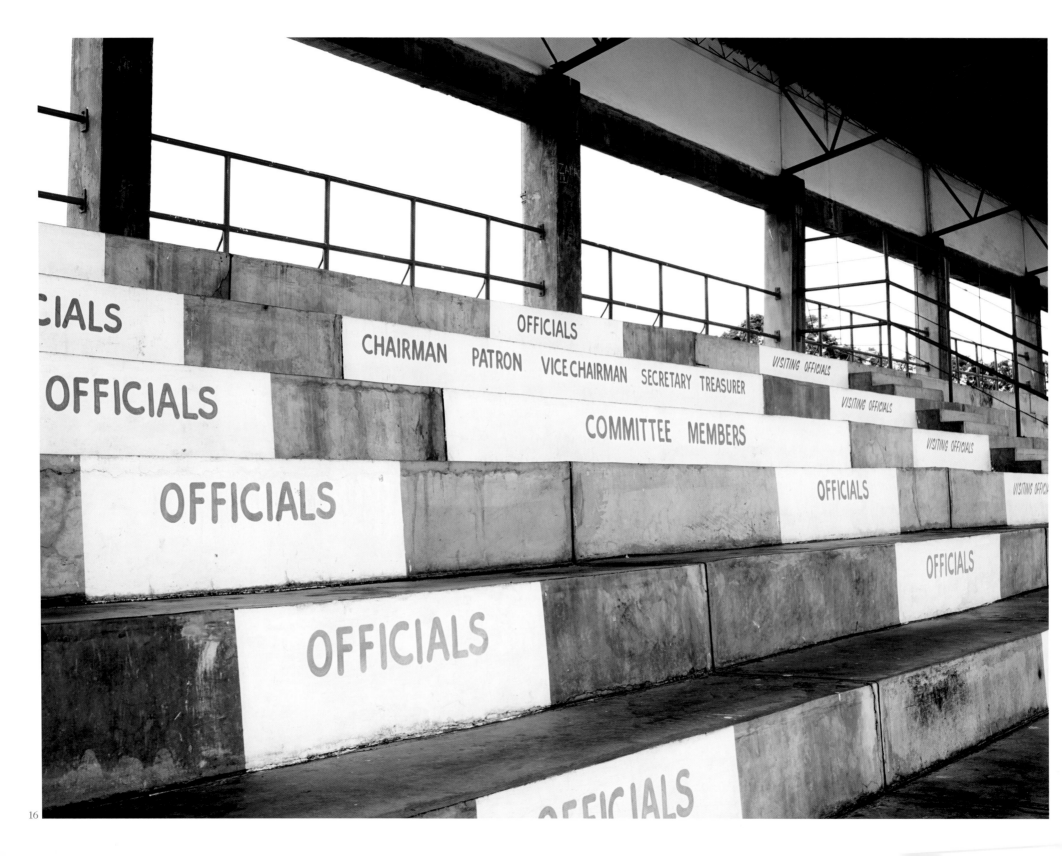

Sunset Stadium, Lusaka, Zambia, 2007

Queensmead Stadium, Lusaka, Zambia, 2007

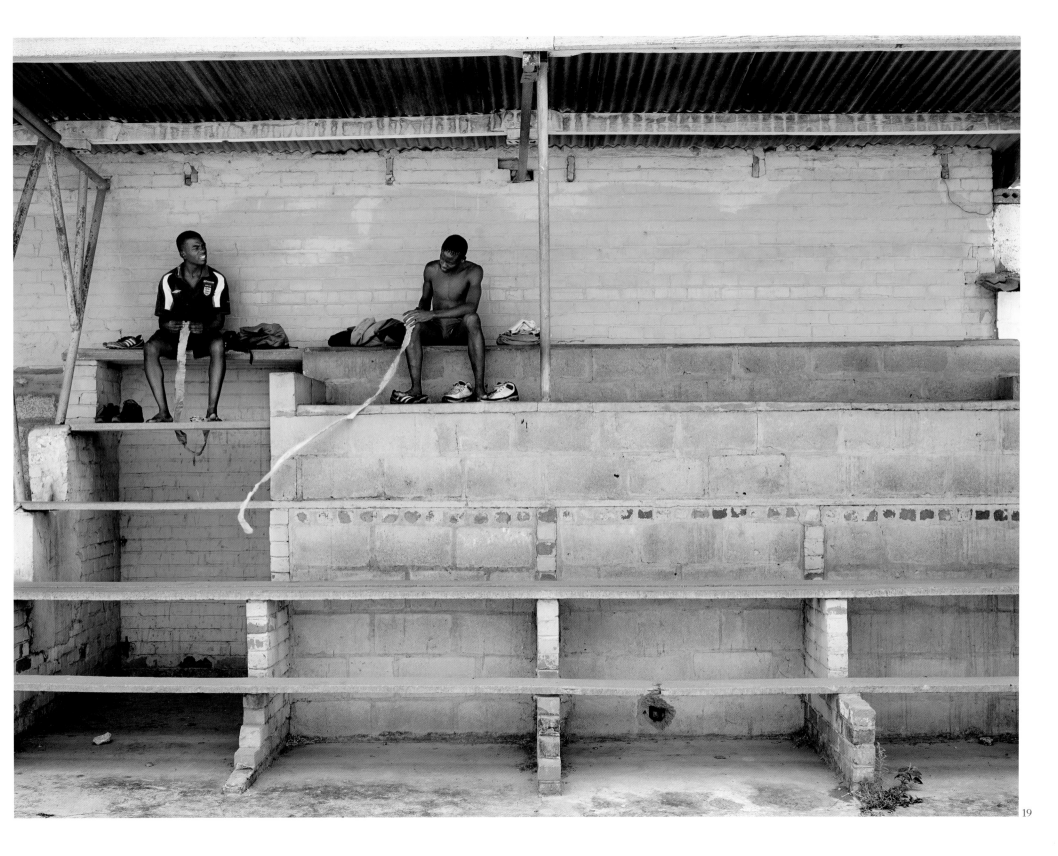

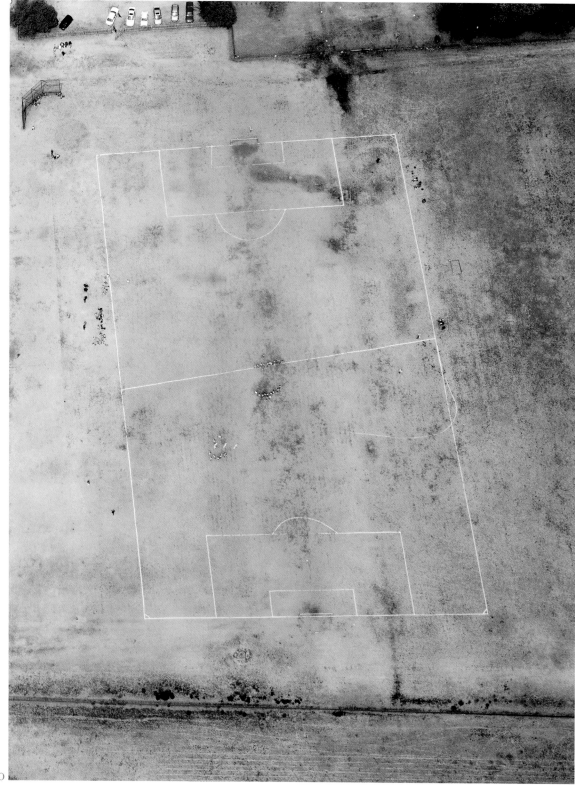

Soweto, Johannesburg, South Africa, 2009

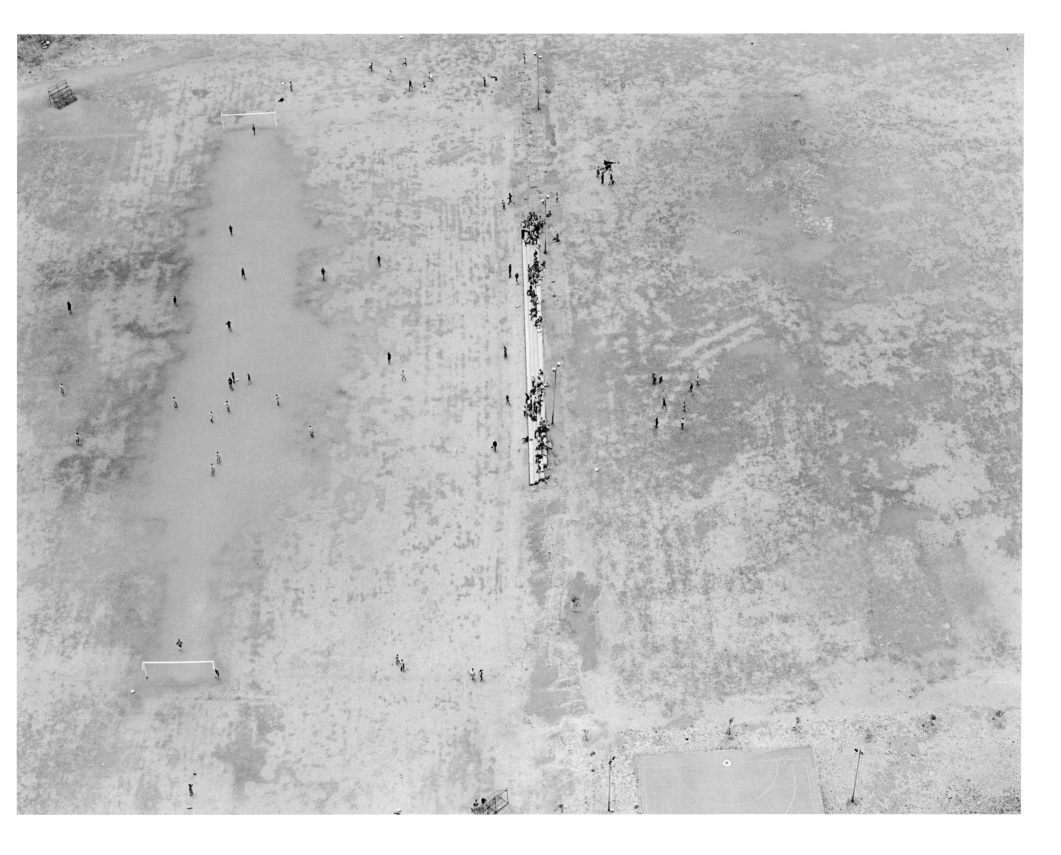

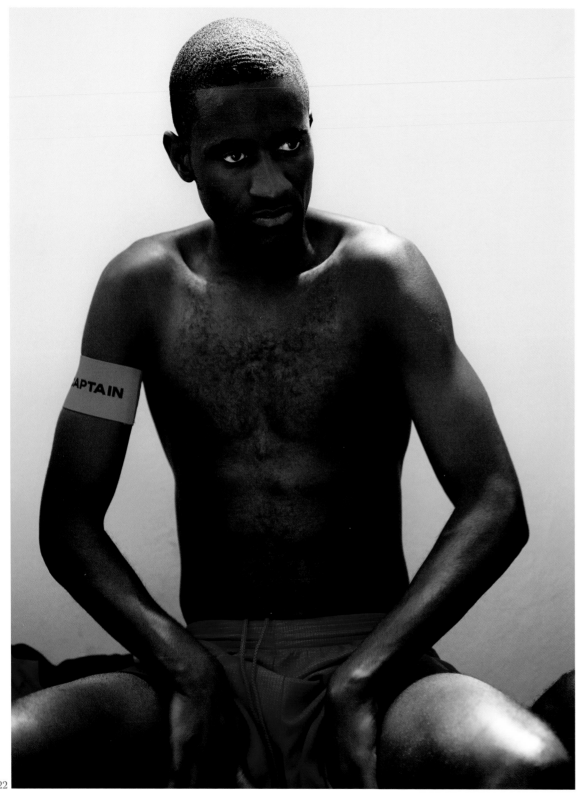

Players from Civics FC, Windhoek, Namibia, 2007

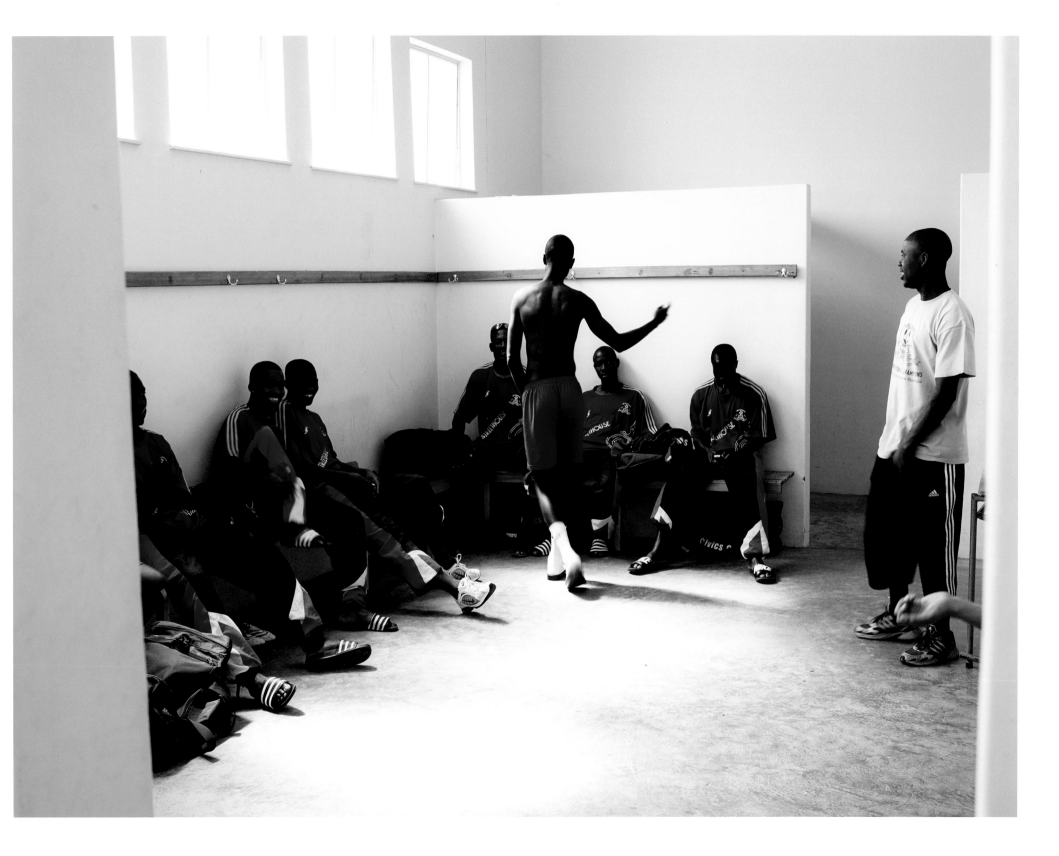

A player from Lusaka Dynamos Football Club, Lusaka, Zambia, 2007

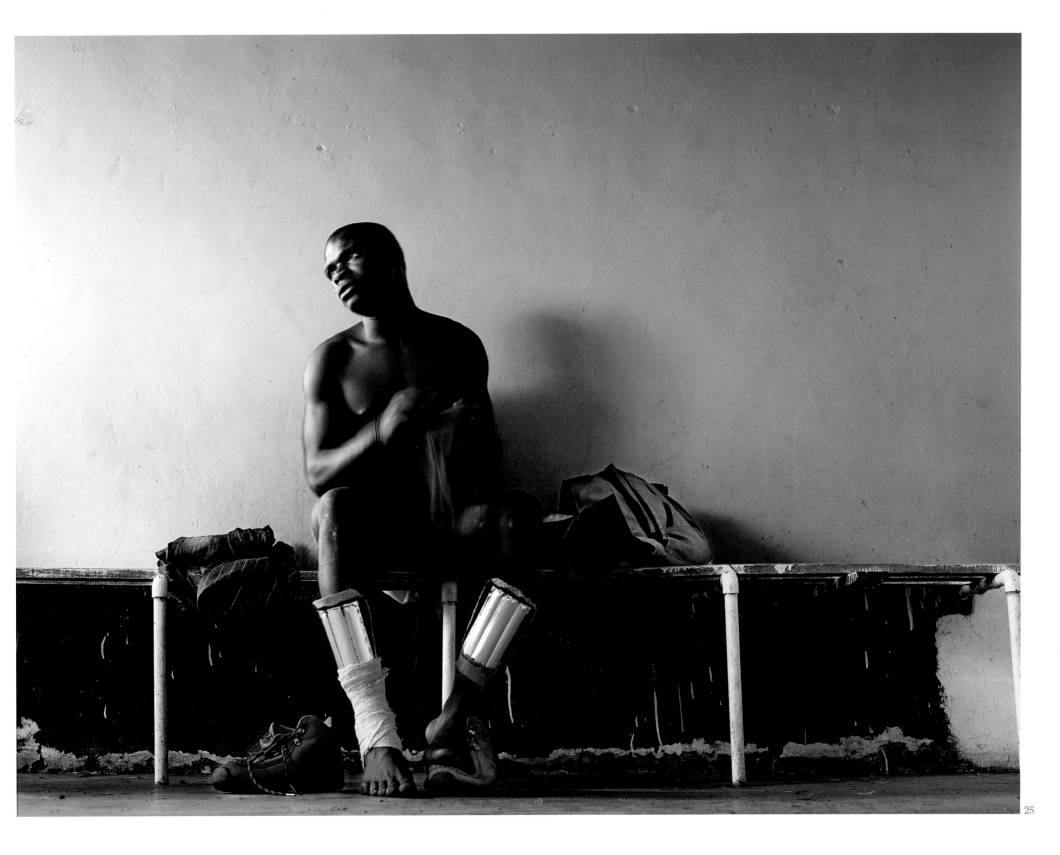

Independence Stadium, Windhoek, Namibia, 2007

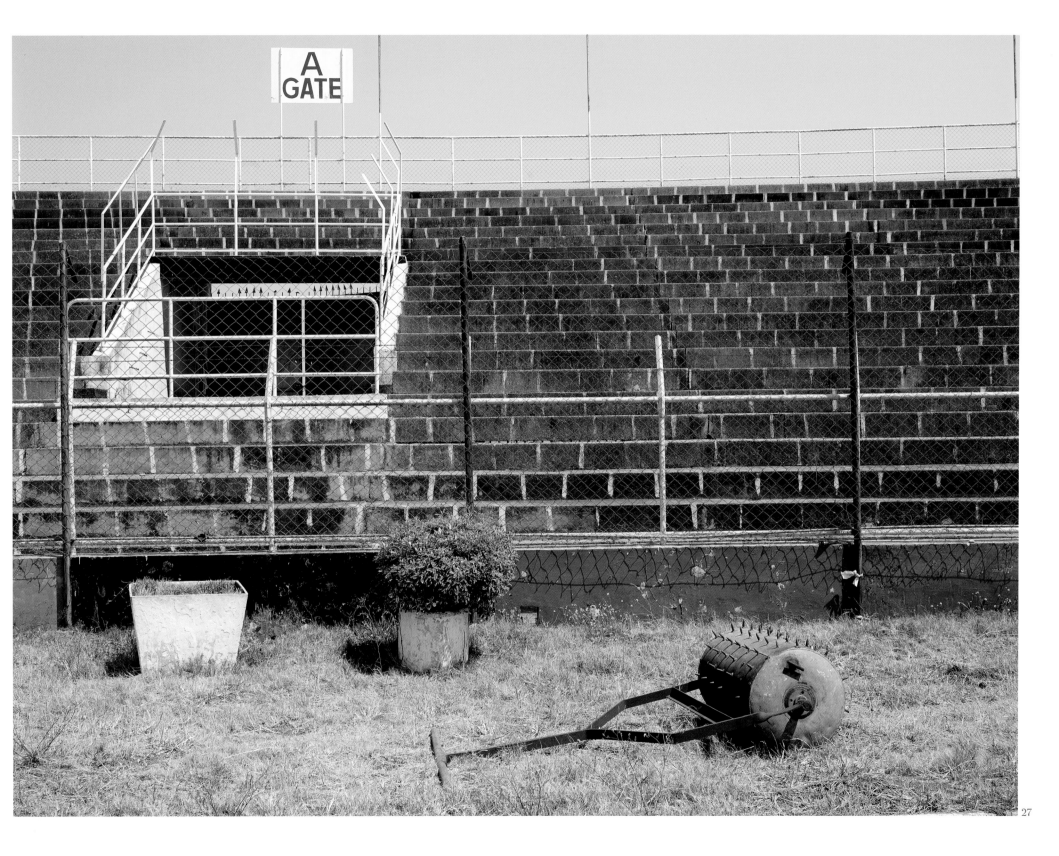

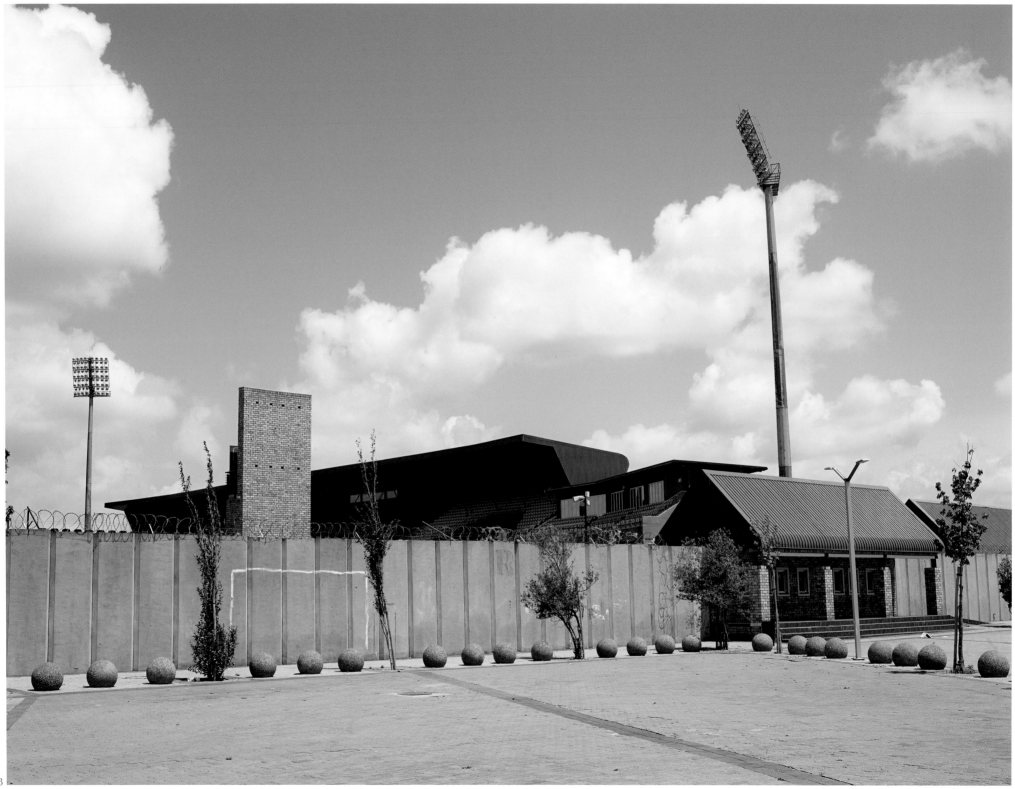

Soweto, Johannesburg, South Africa, 2007

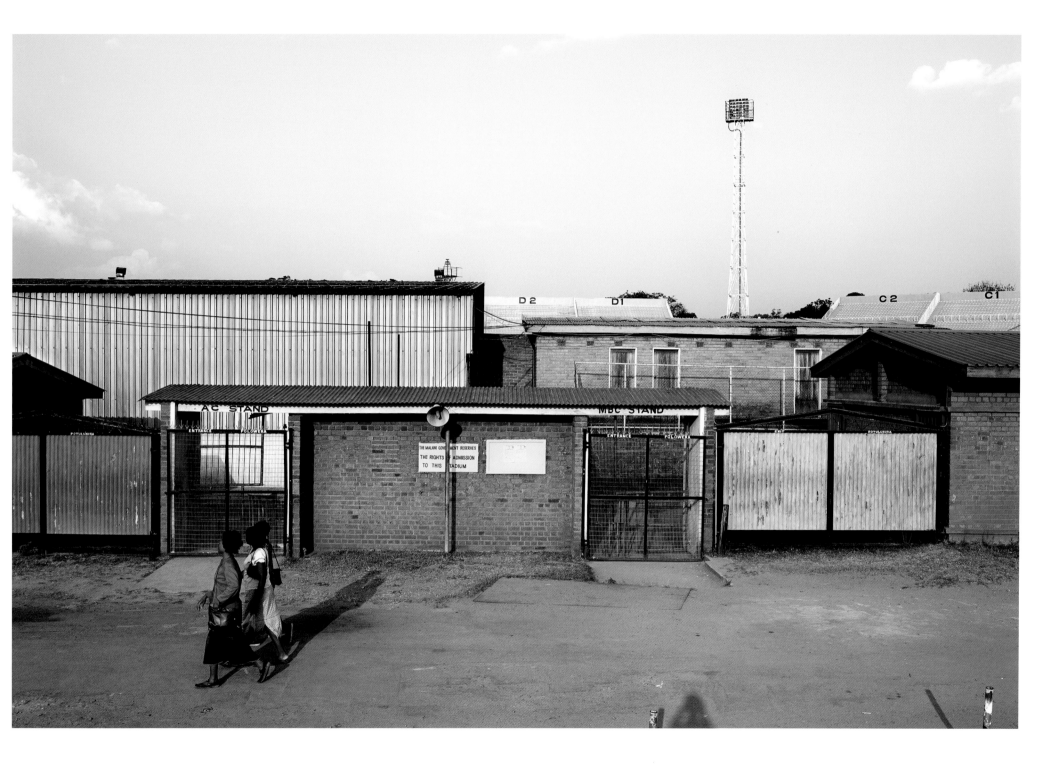

Kamuzu Stadium, Blantyre, Malawi, 2009

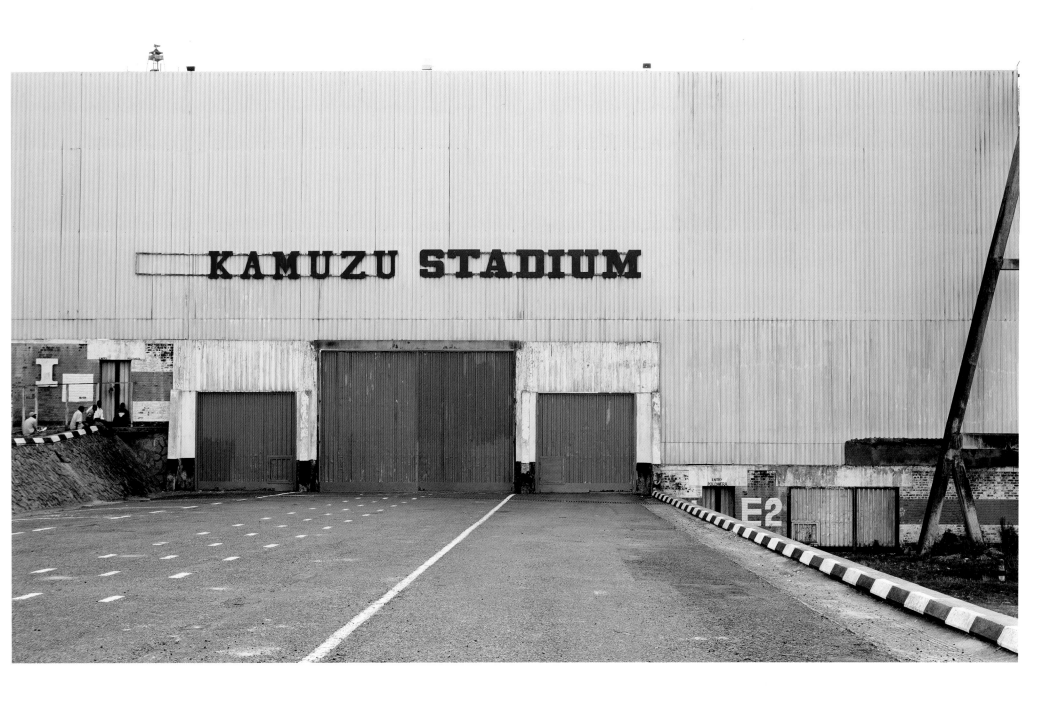

Kamuzu Stadium, Blantyre, Malawi, 2009

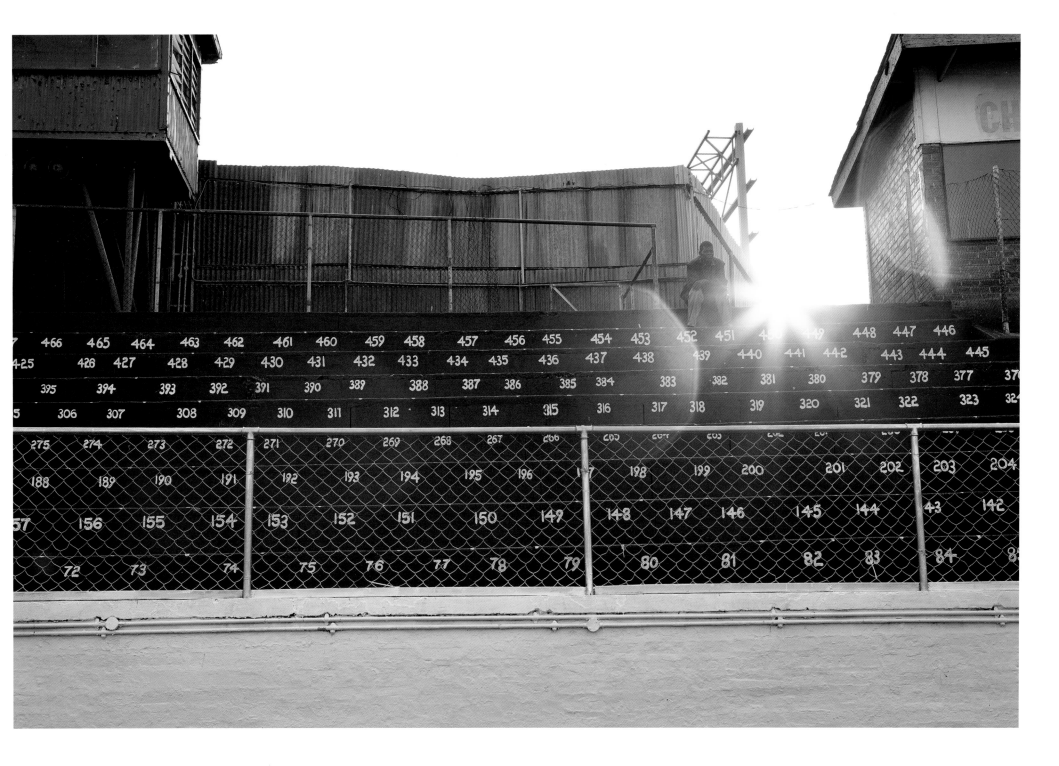

Kamuzu Stadium, Blantyre, Malawi, 2009

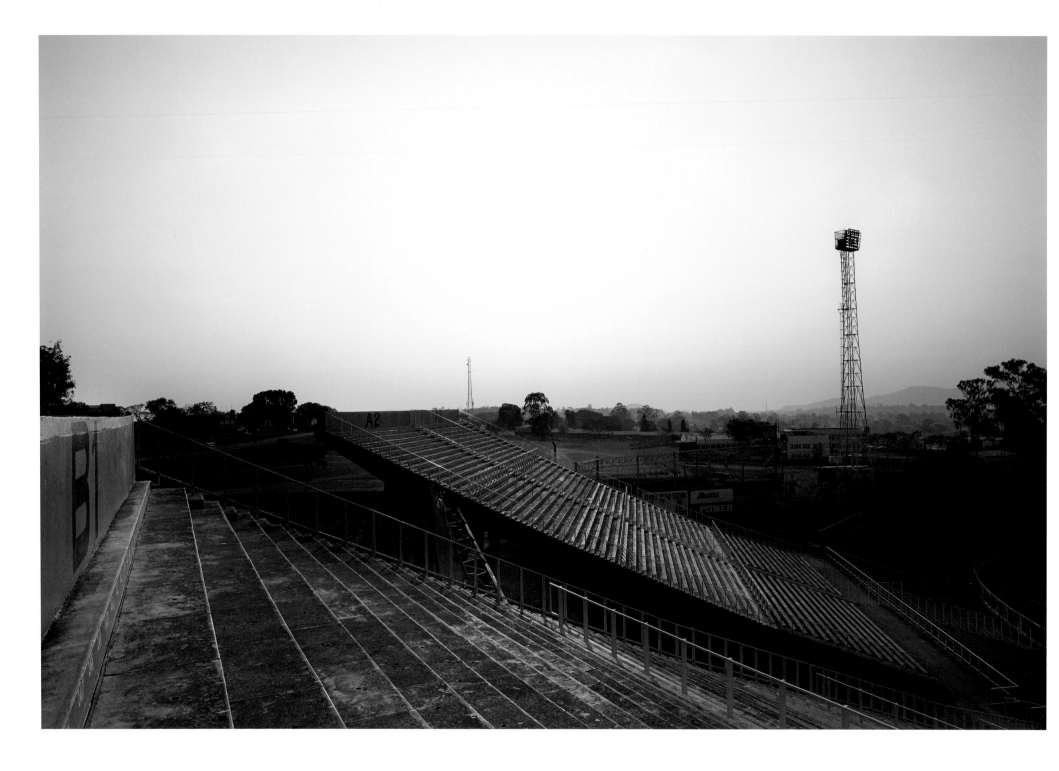

Kamuzu Stadium, Blantyre, Malawi, 2009

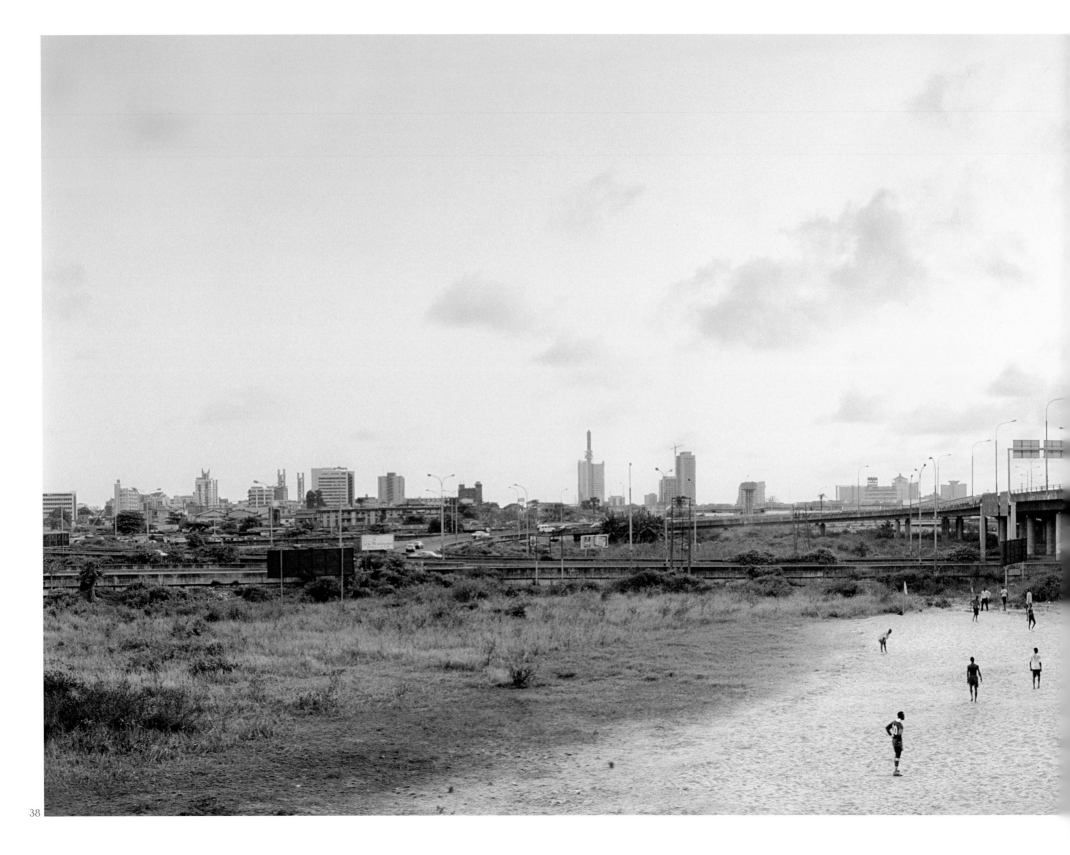

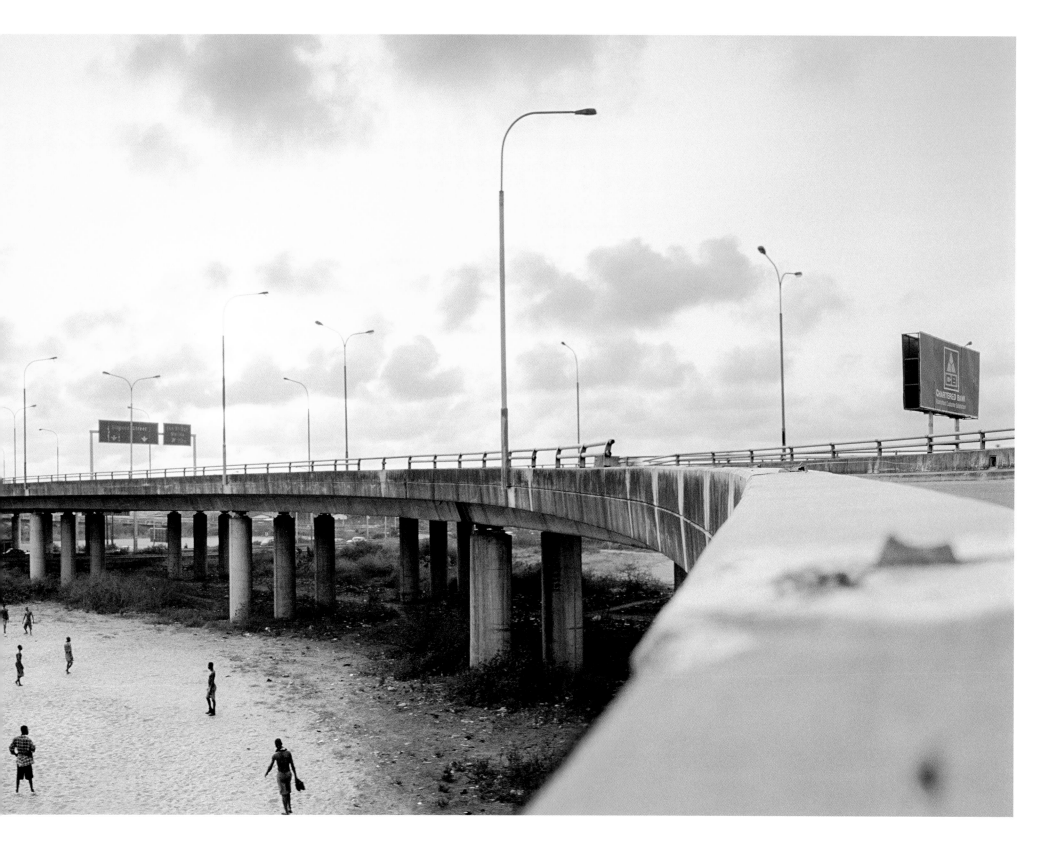

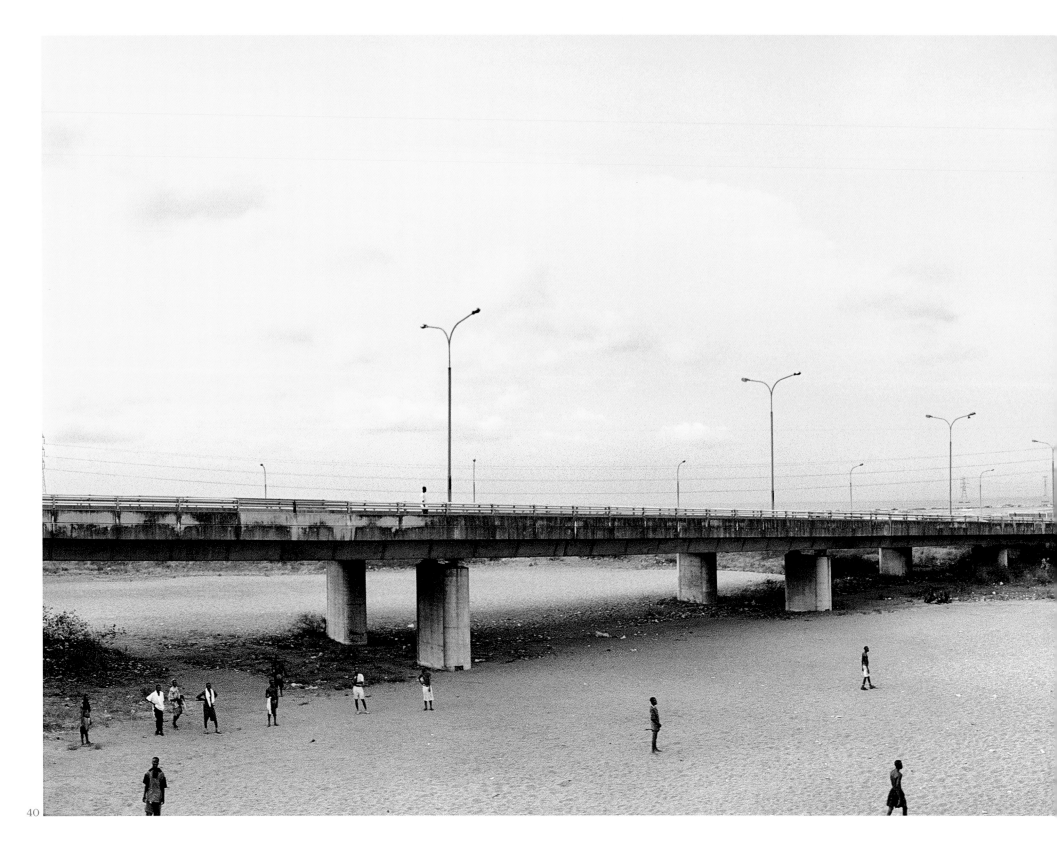

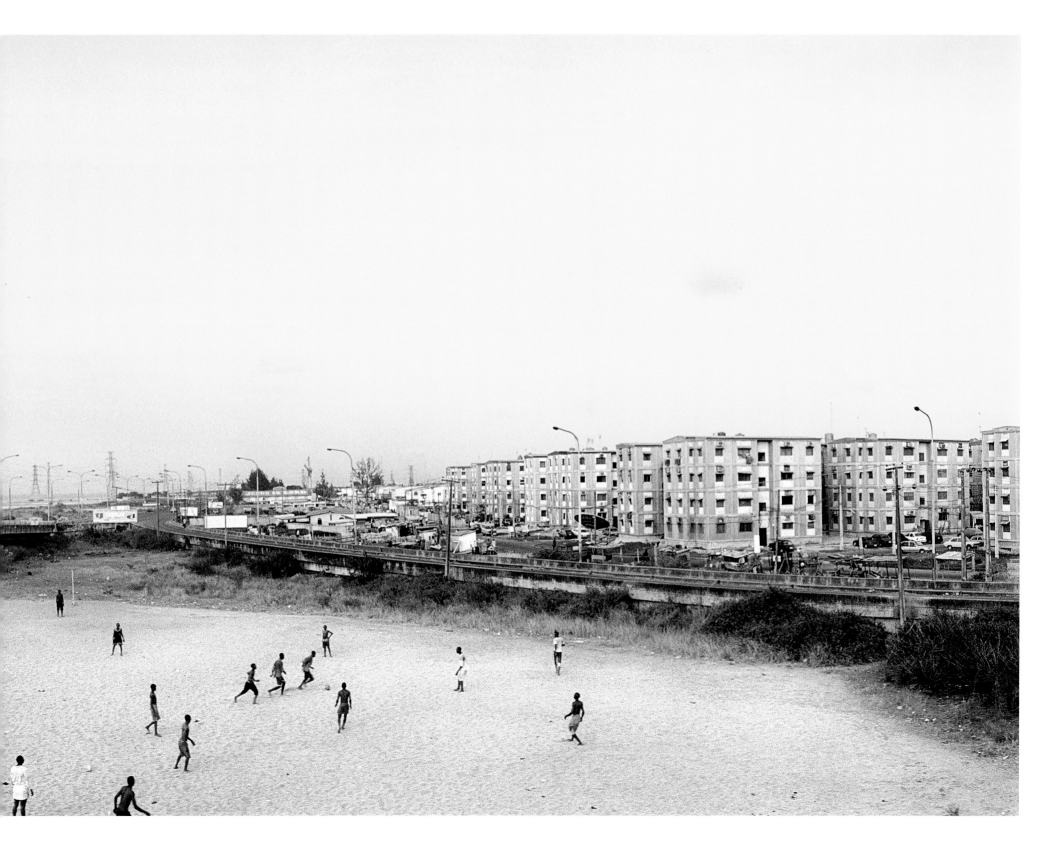

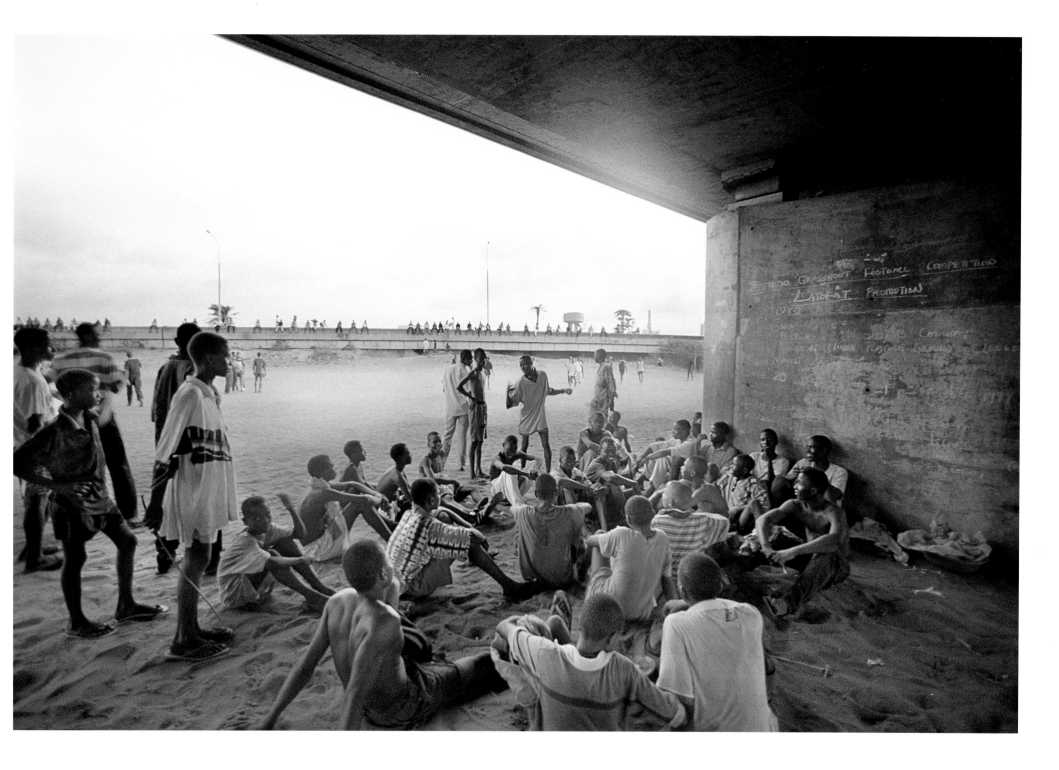

Lagos, Nigeria, 1999

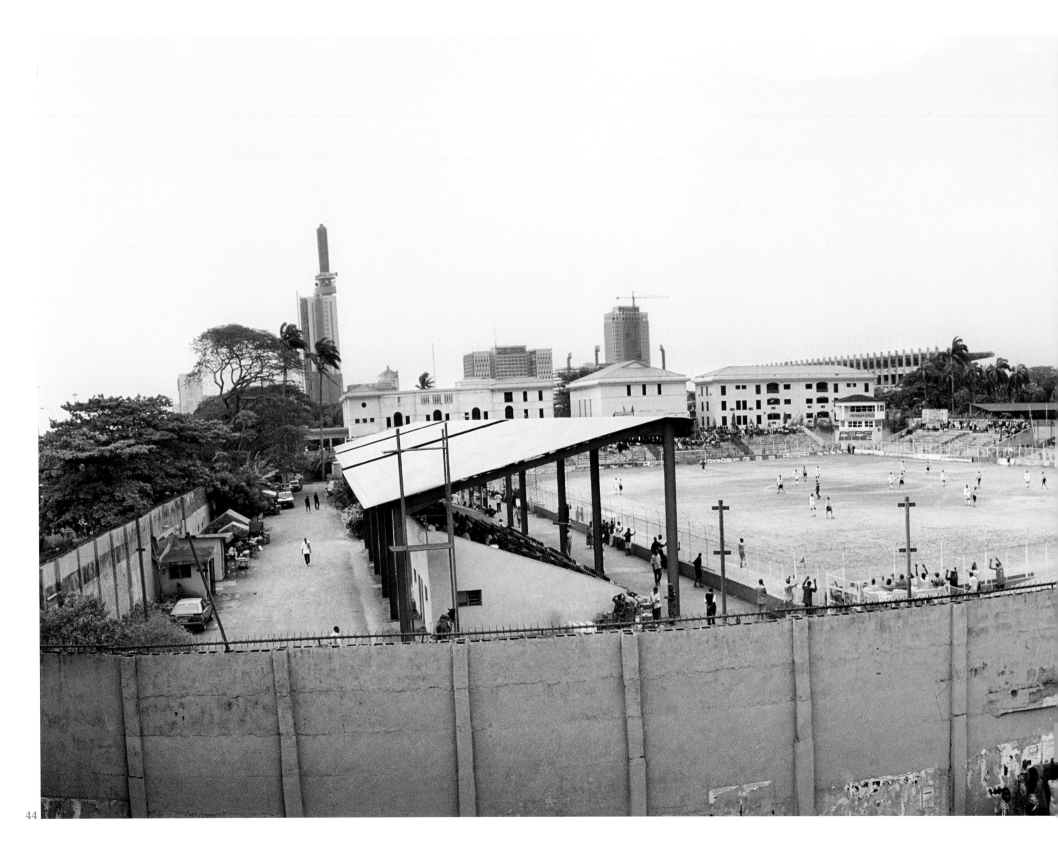

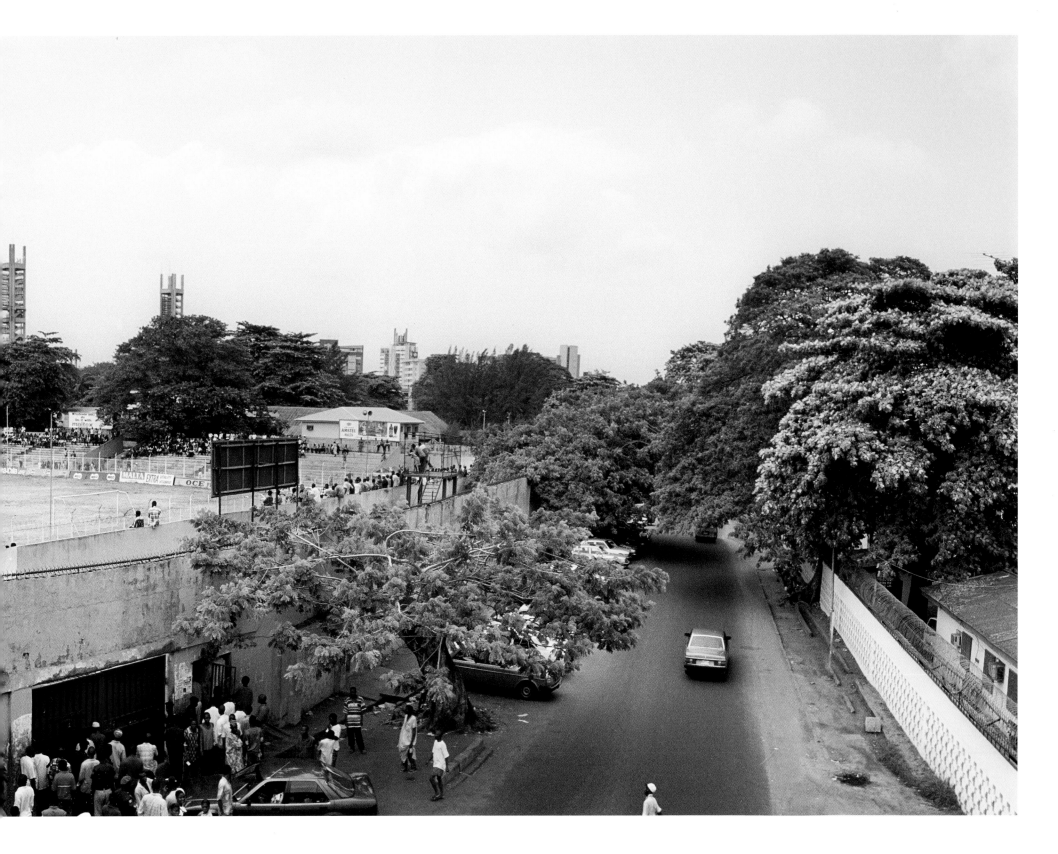

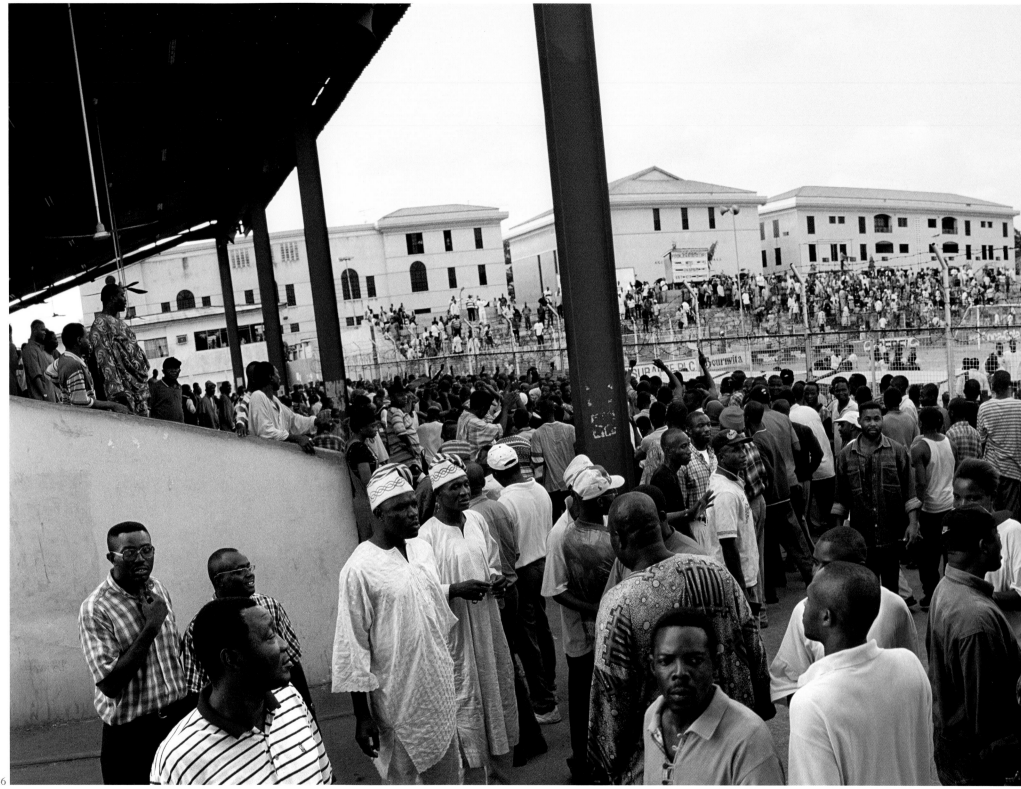

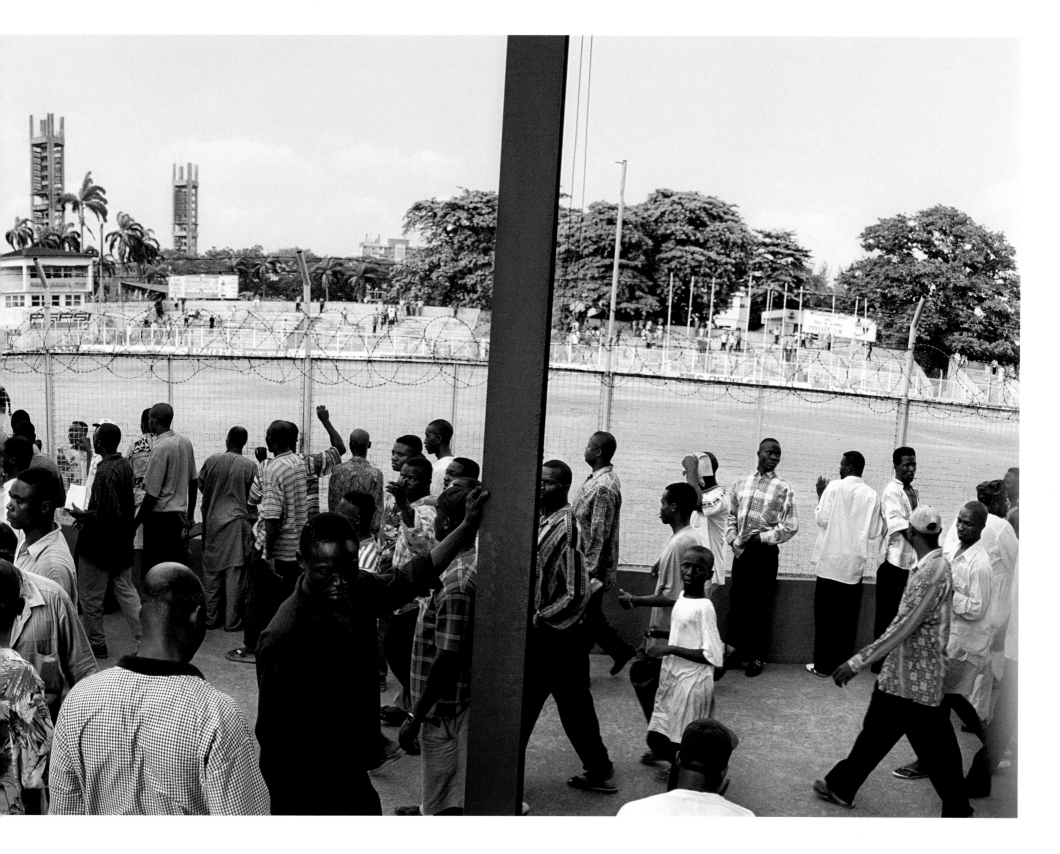

Pages 44–47: Onikan Stadium, Lagos, Nigeria, 1999

Pages 48 & 49: Abuja, Nigeria, 1999

Choma, Zambia, 2007

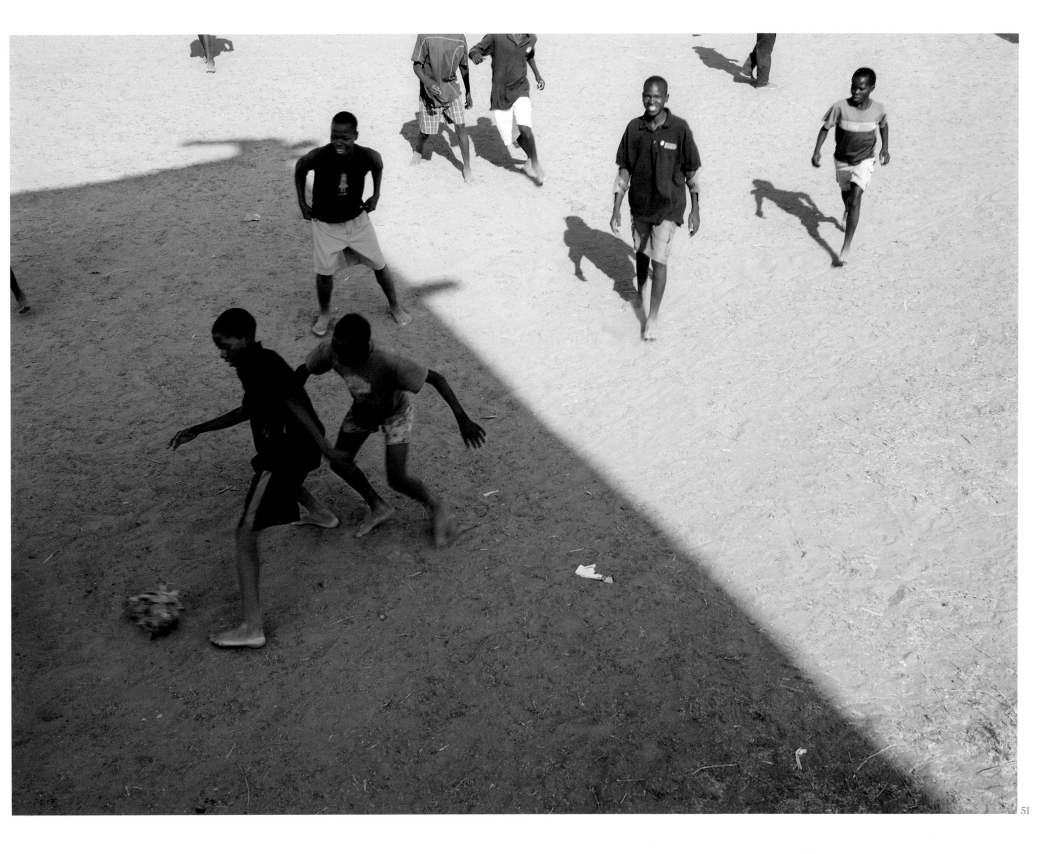

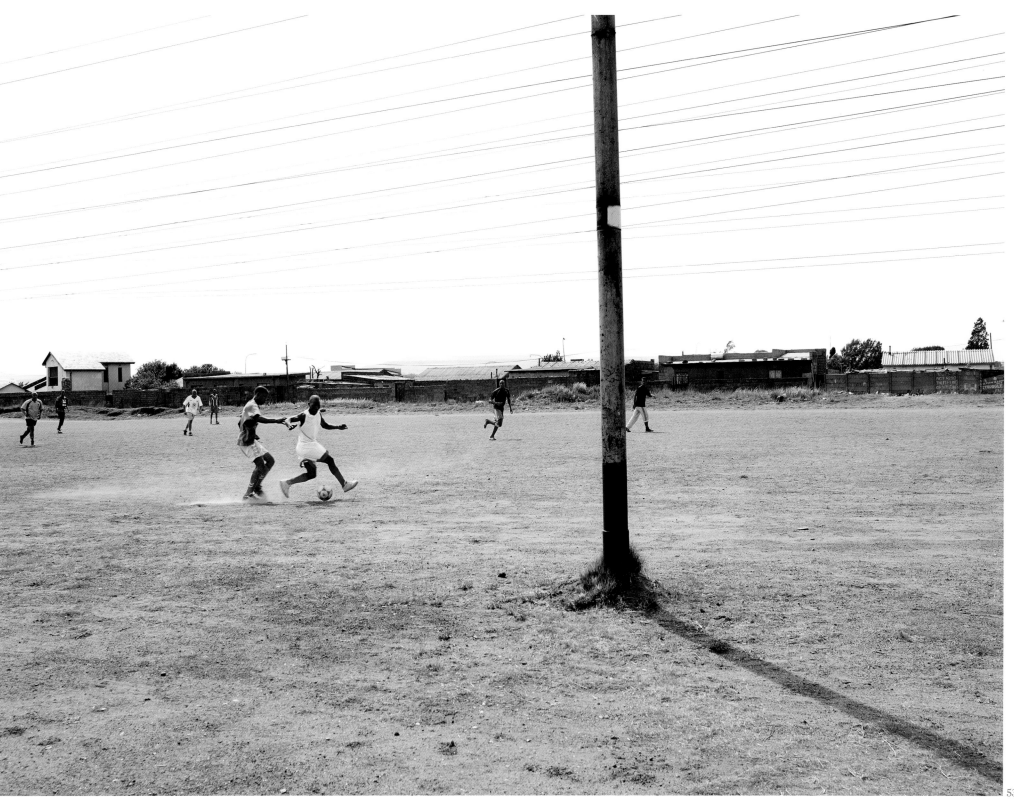

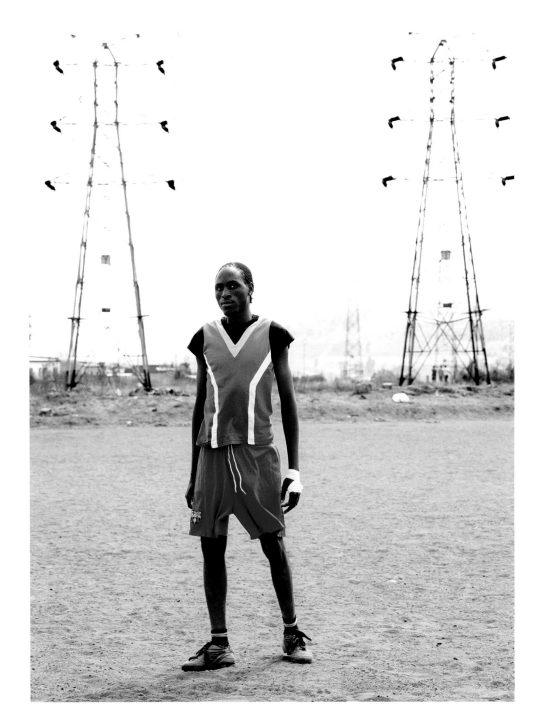

Players in Diepkloof, Johannesburg, South Africa, 2009

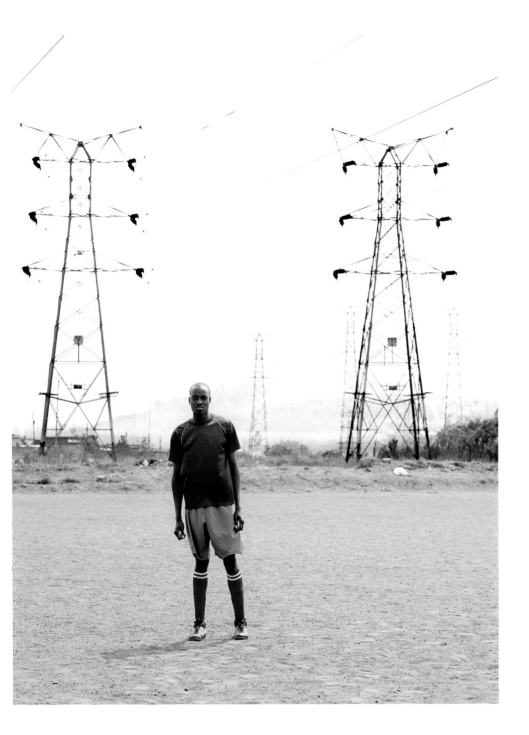

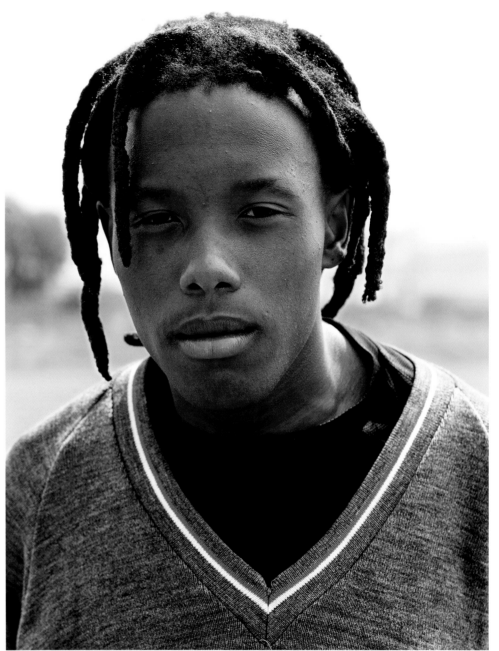

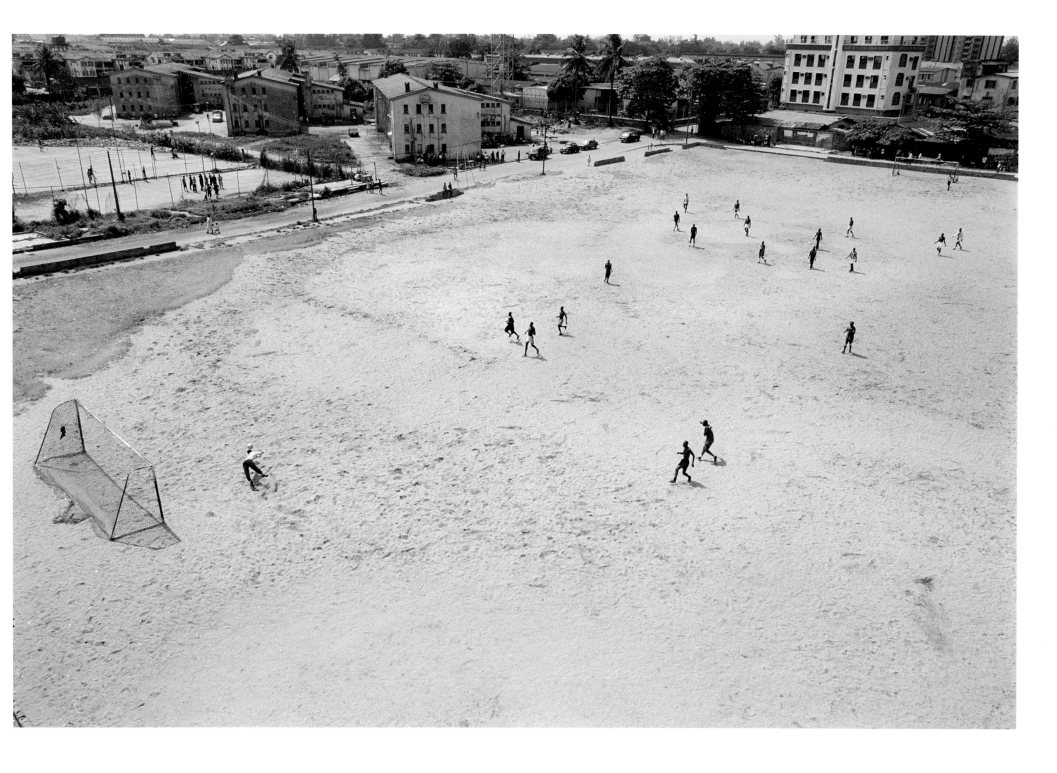

Lagos, Nigeria, 1999

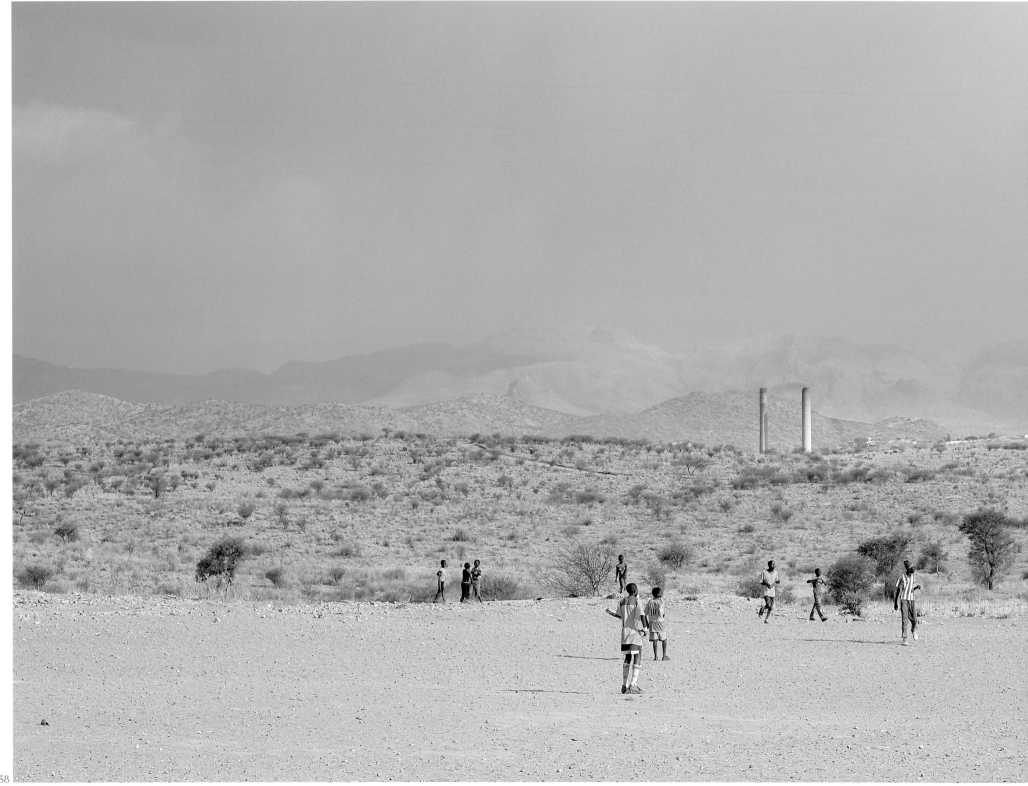

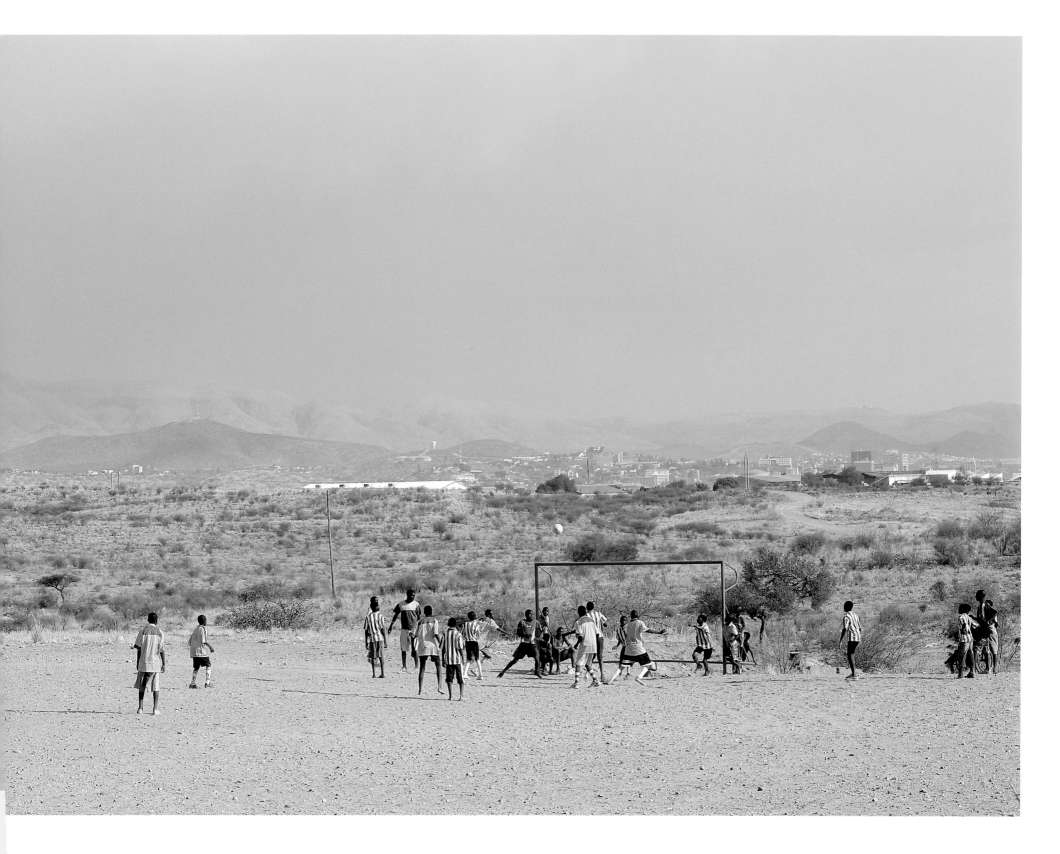

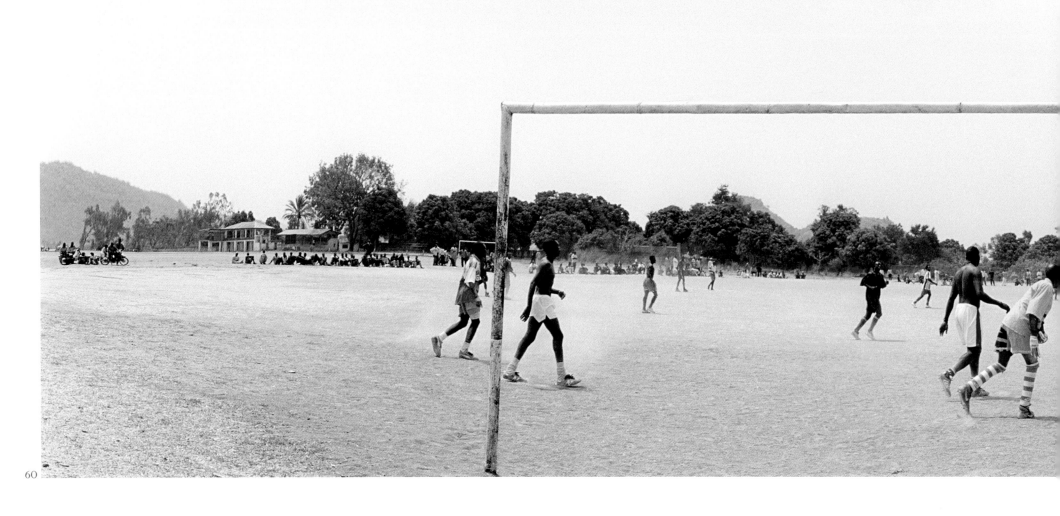

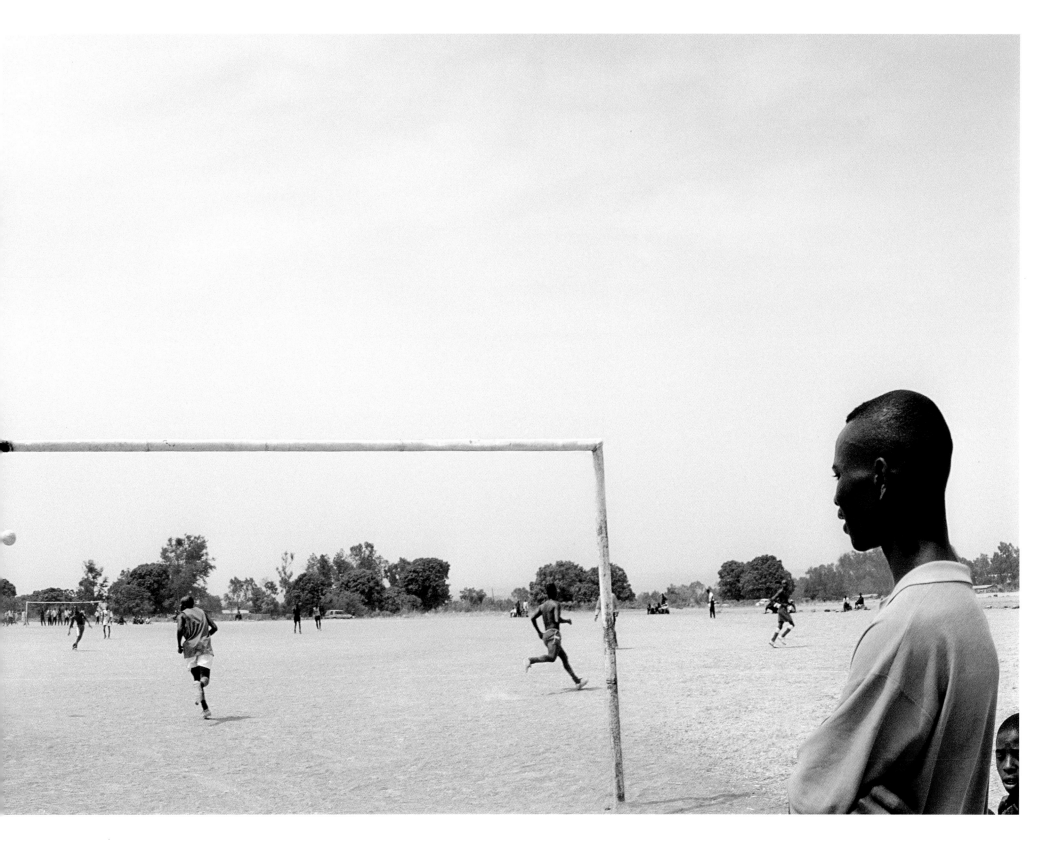

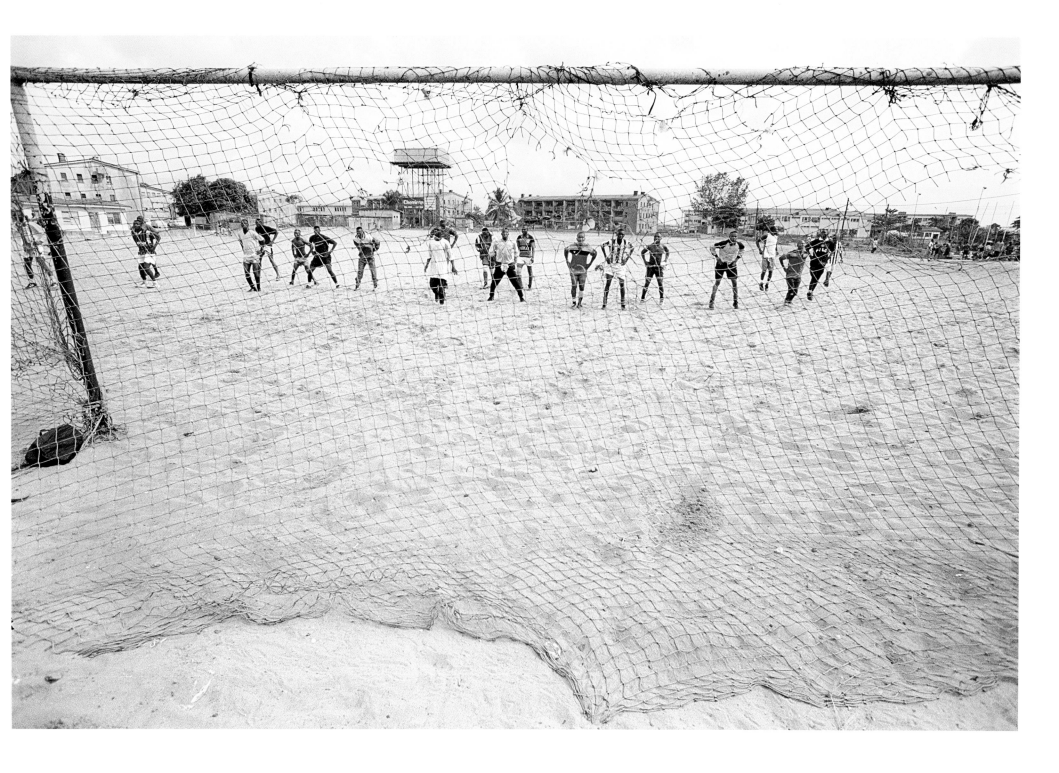

Pages 58 & 59: Babylon, Namibia, 2007
Pages 60 & 61: Abuja, Nigeria, 1999

Lagos, Nigeria, 2007

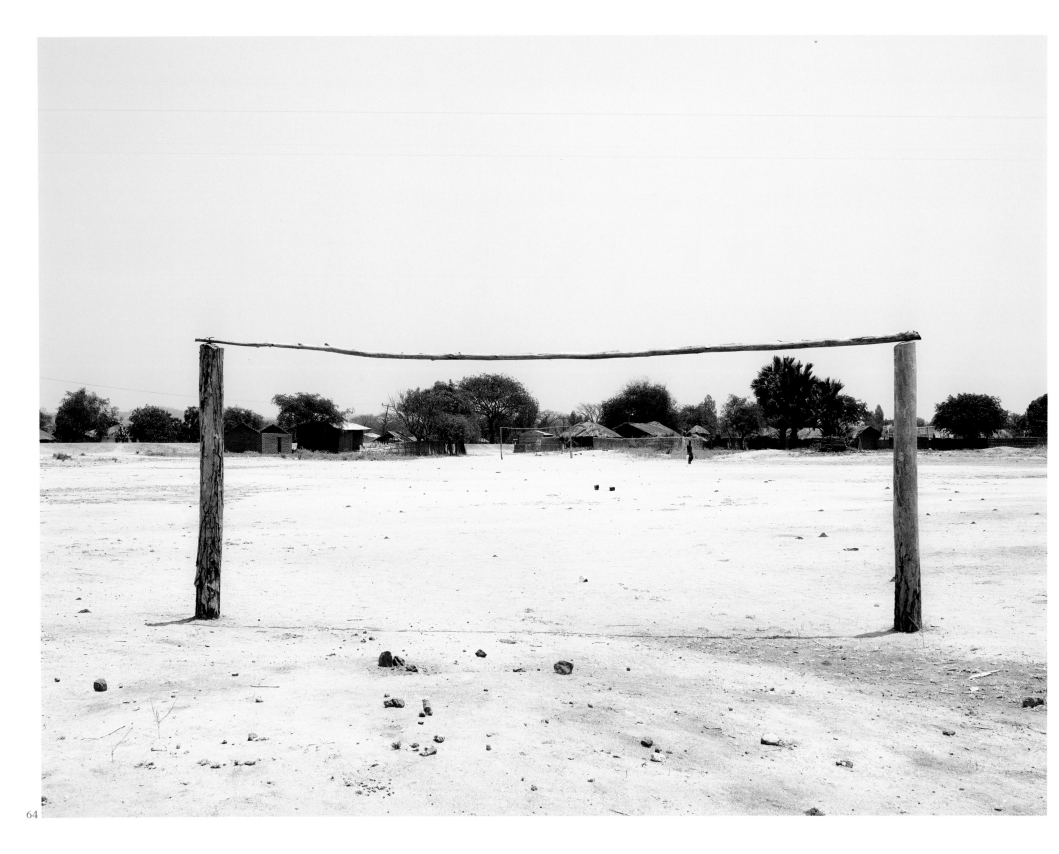

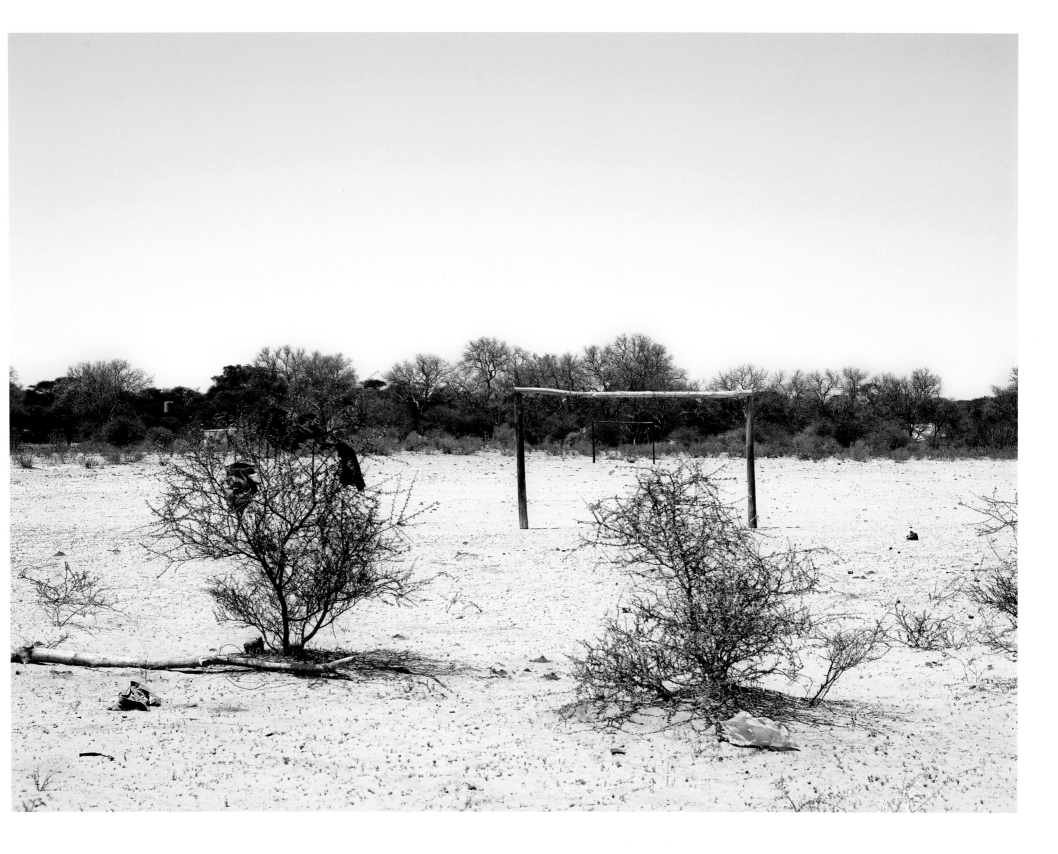

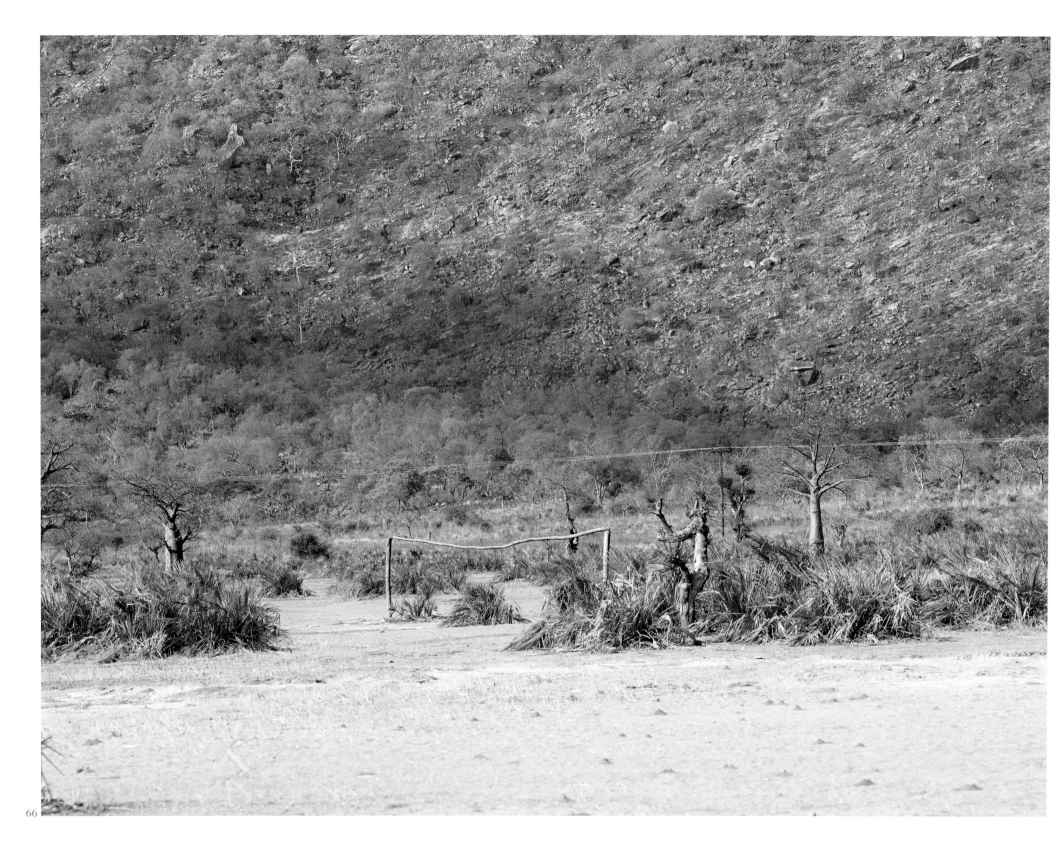

Pages 64 & 65: Mangochi, Malawi, 2009 & Maun, Botswana, 2007

Kasankha Village, Cape MacLear, Malawi, 2009

Kalomo, Zambia, 2007

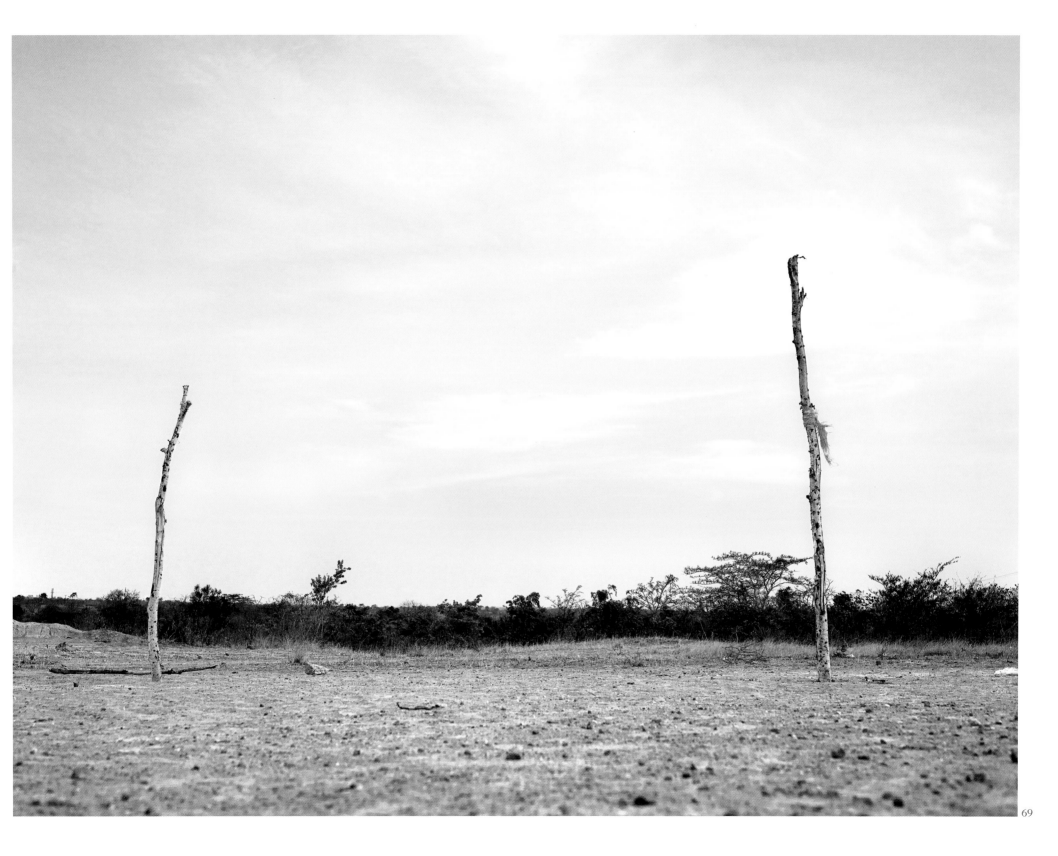

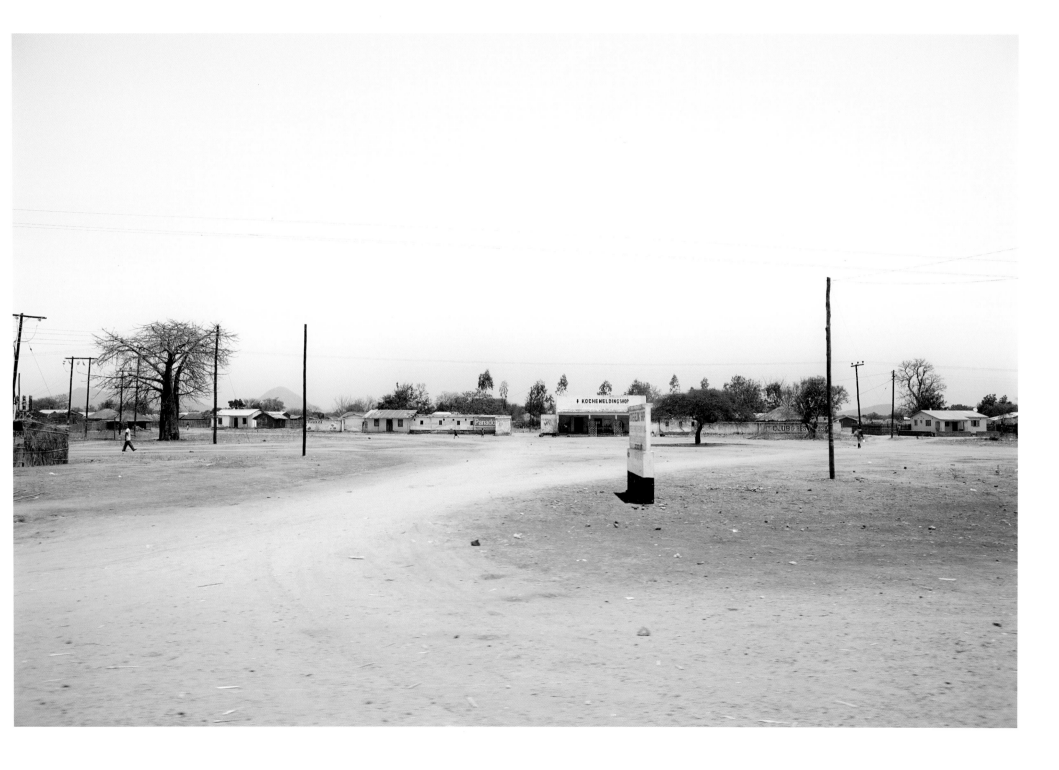

Mangochi, Malawi, 2009

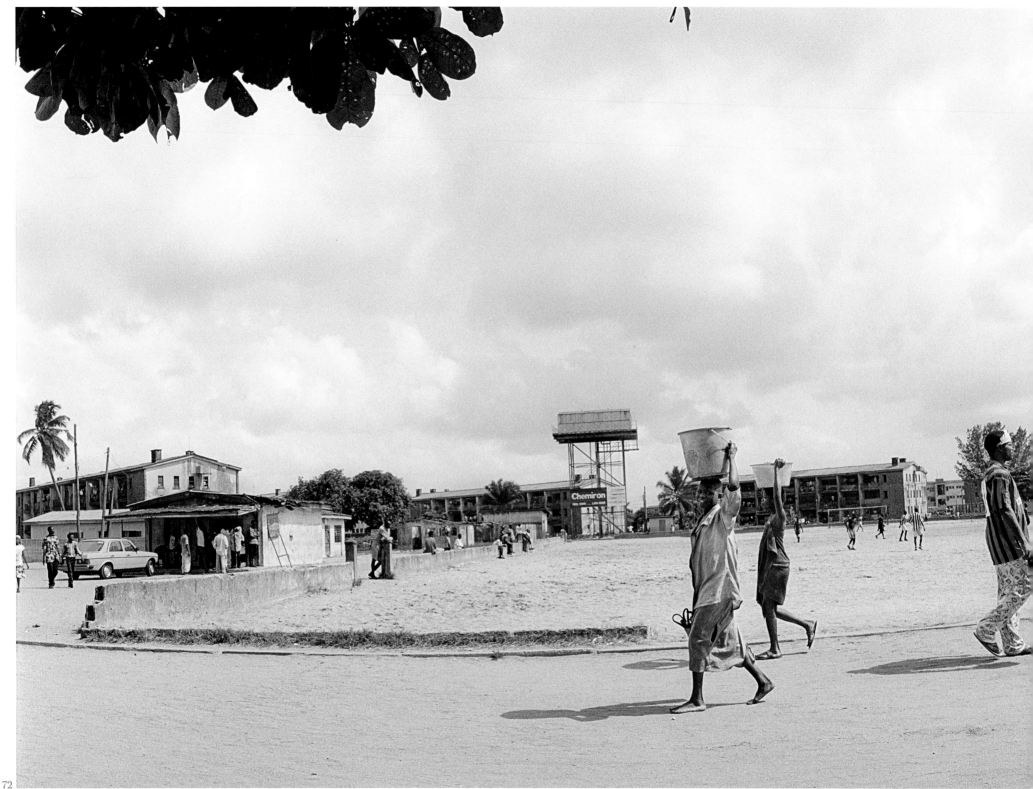

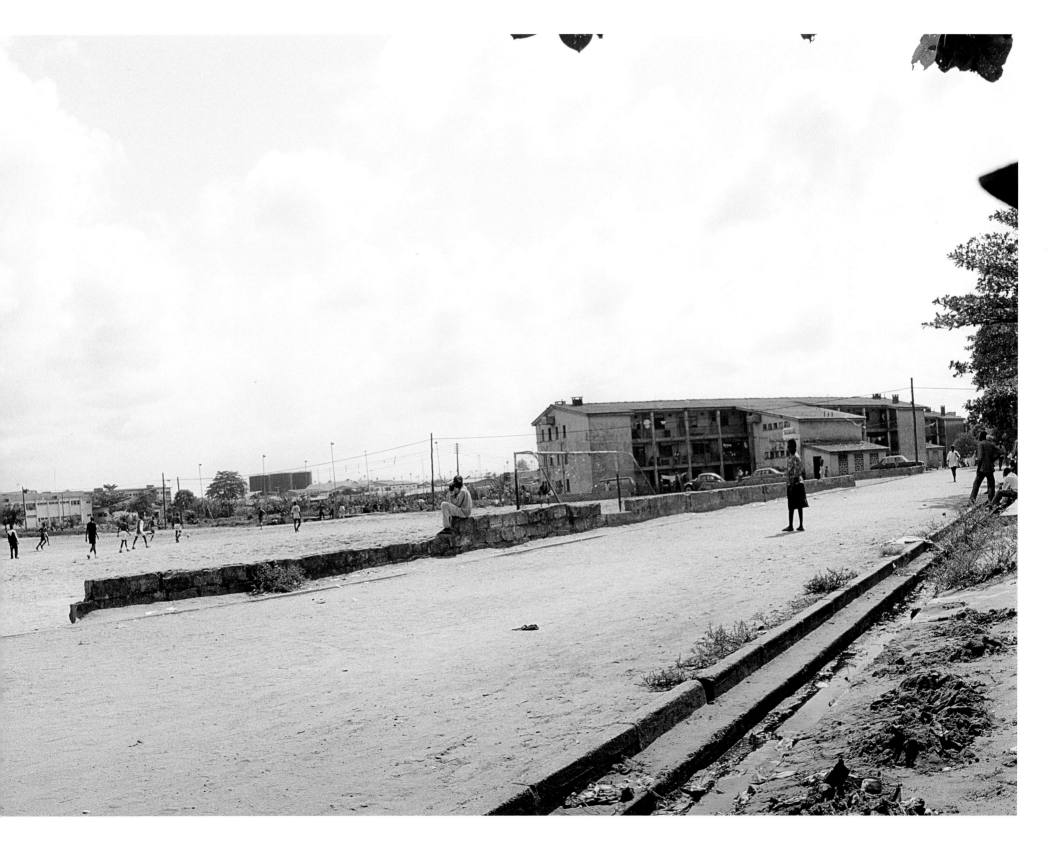

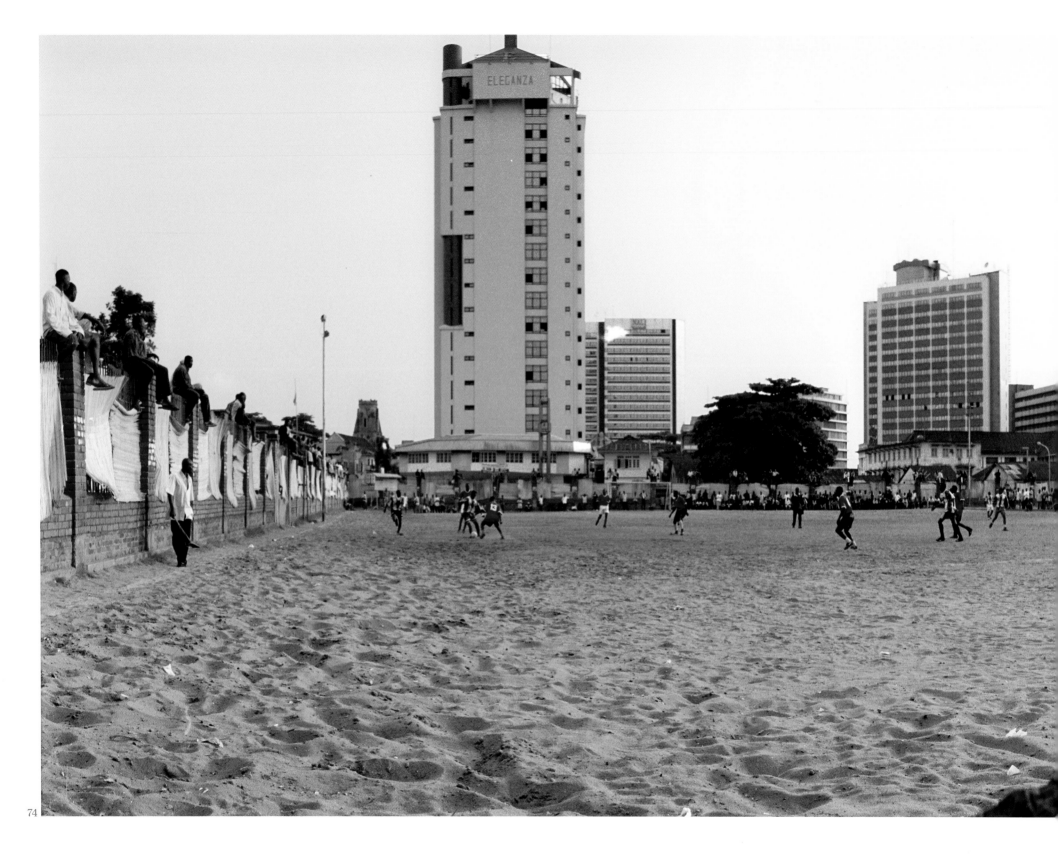

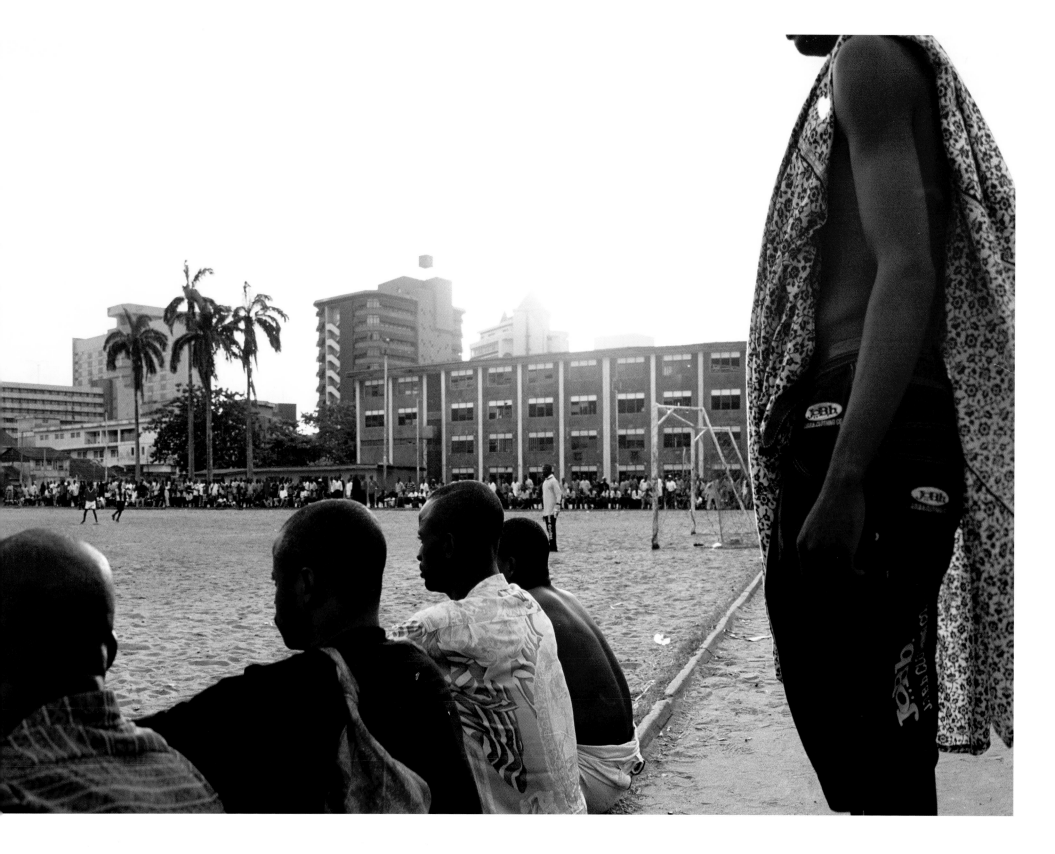

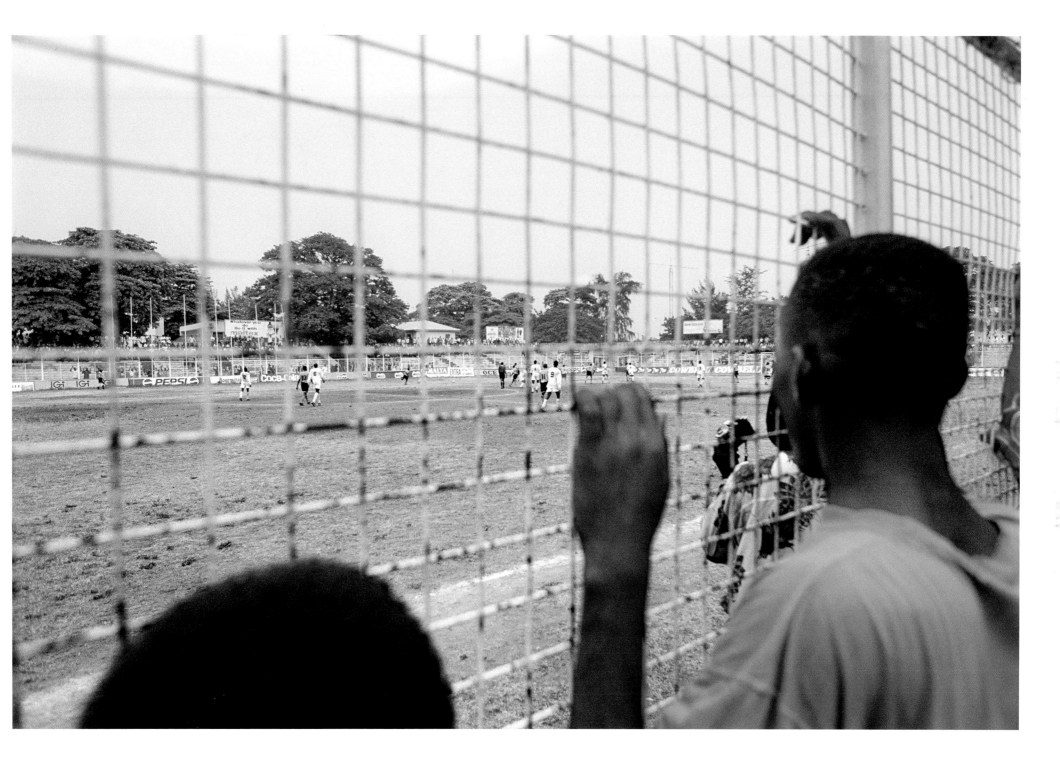

Onikan Stadium, Lagos, Nigeria, 1999

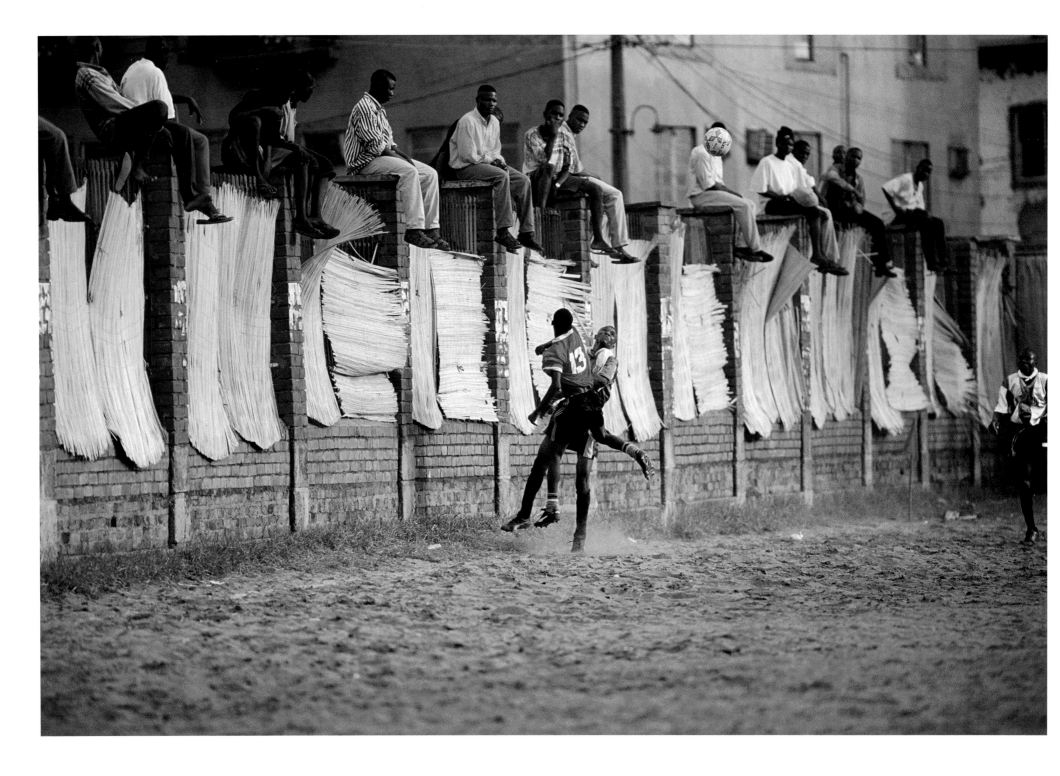

Lagos, Nigeria, 1999

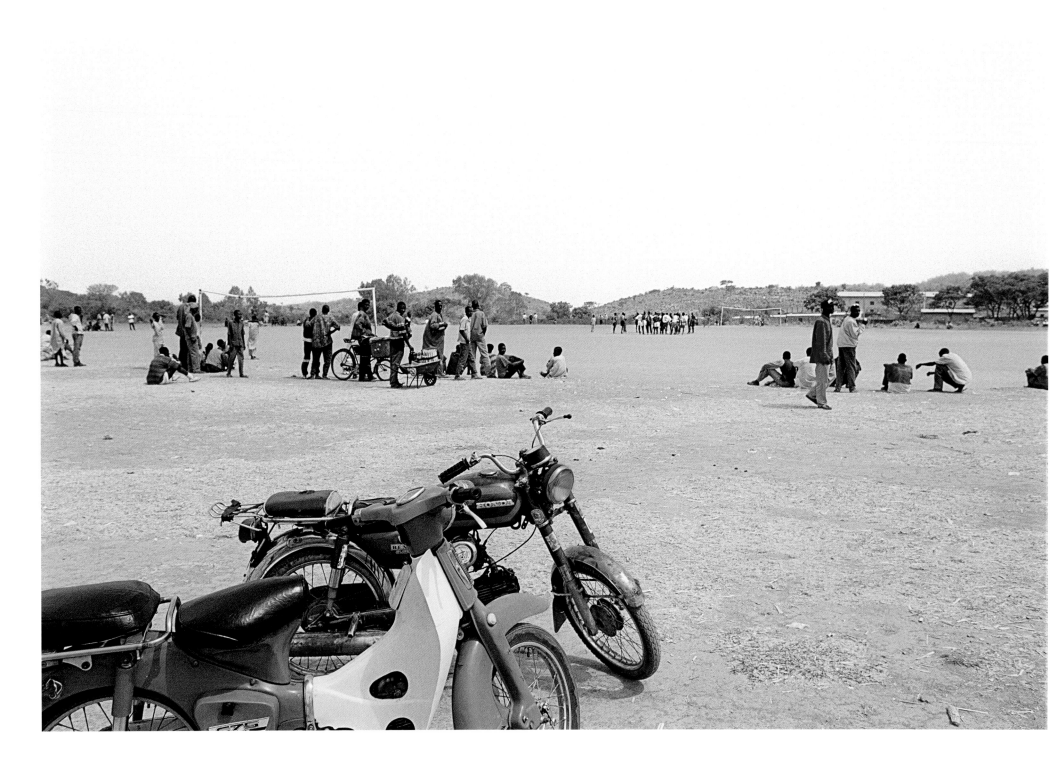

Abuja, Nigeria, 1999

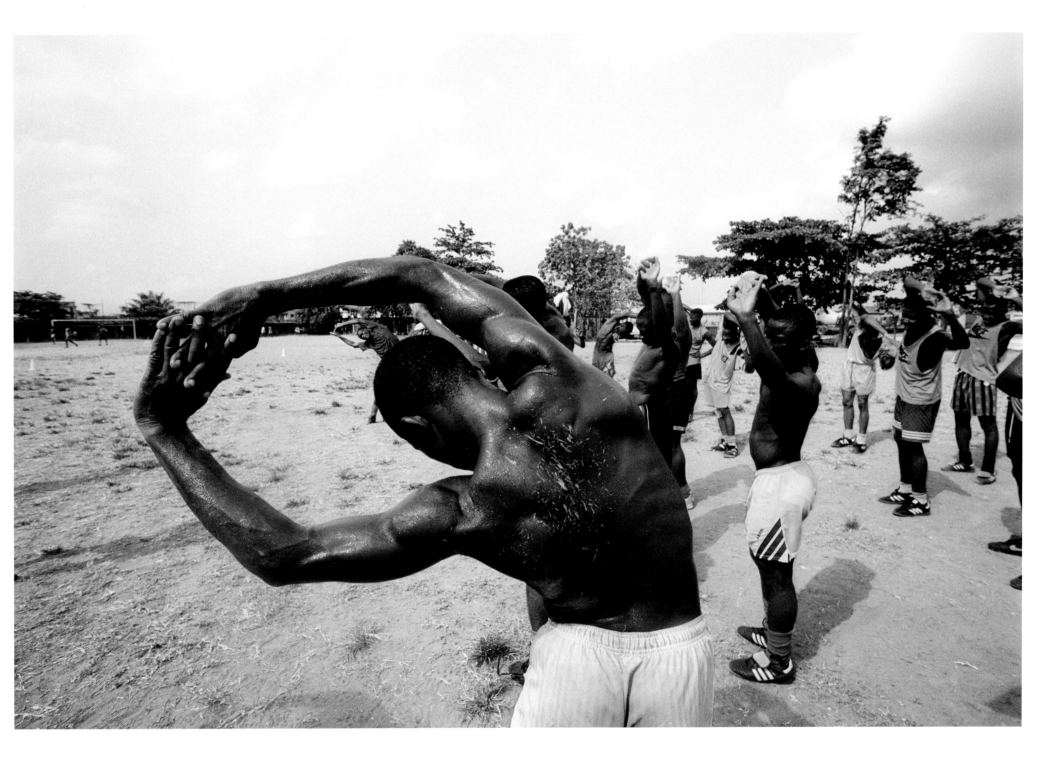

Lagos, Nigeria, 1999

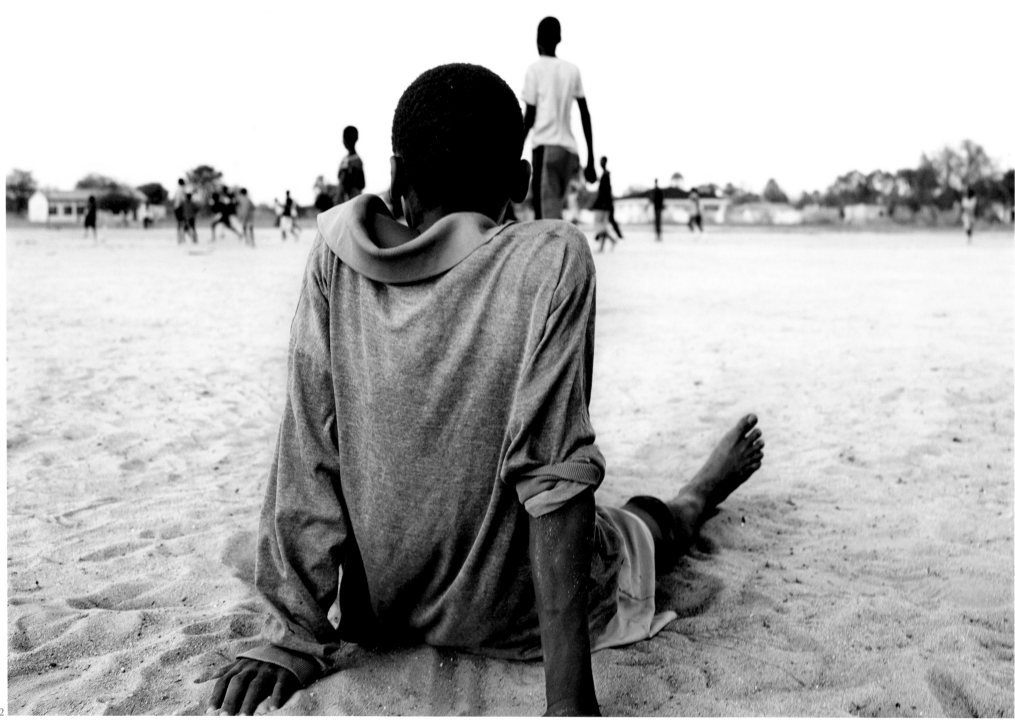

Nata, Botswana, 2007

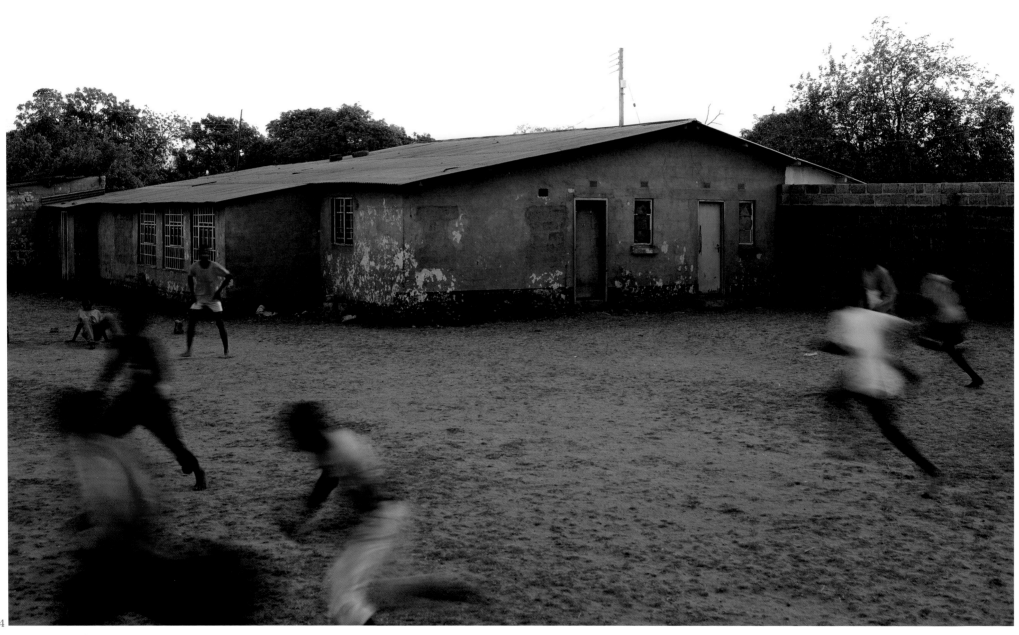

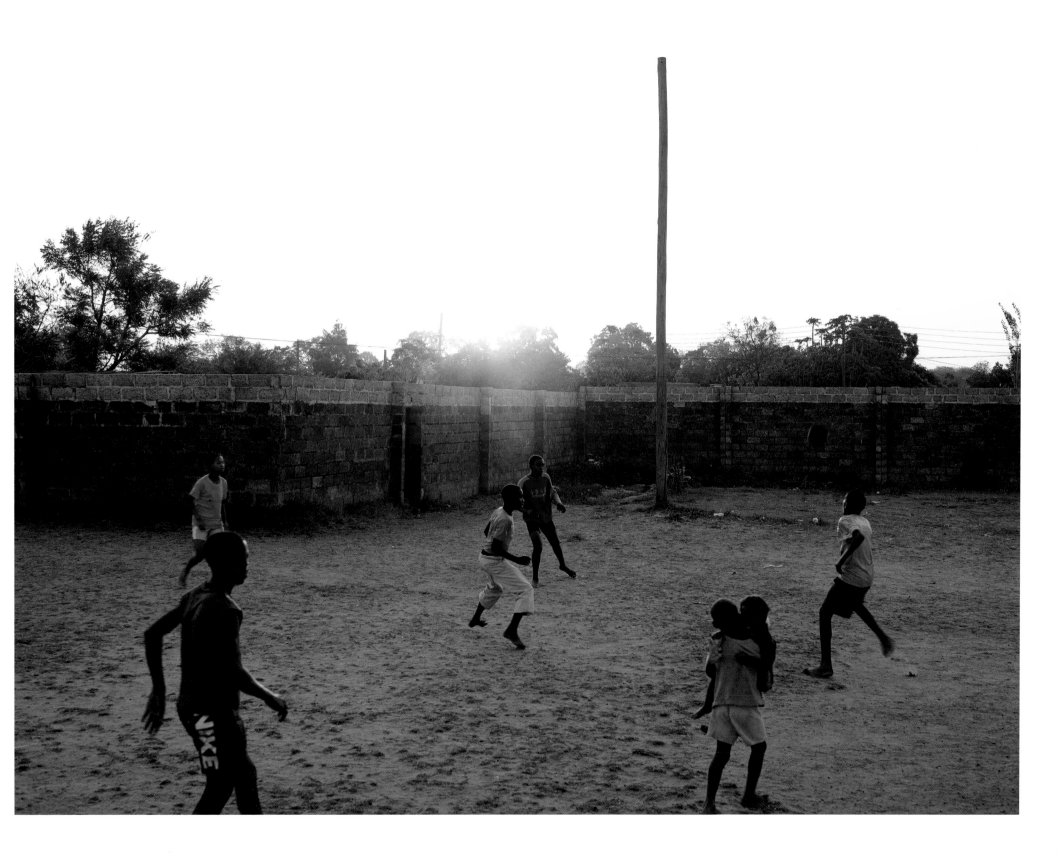

Pages 84 & 85: Lusaka, Zambia, 2007

Sunset Stadium, Lusaka, Zambia, 2007

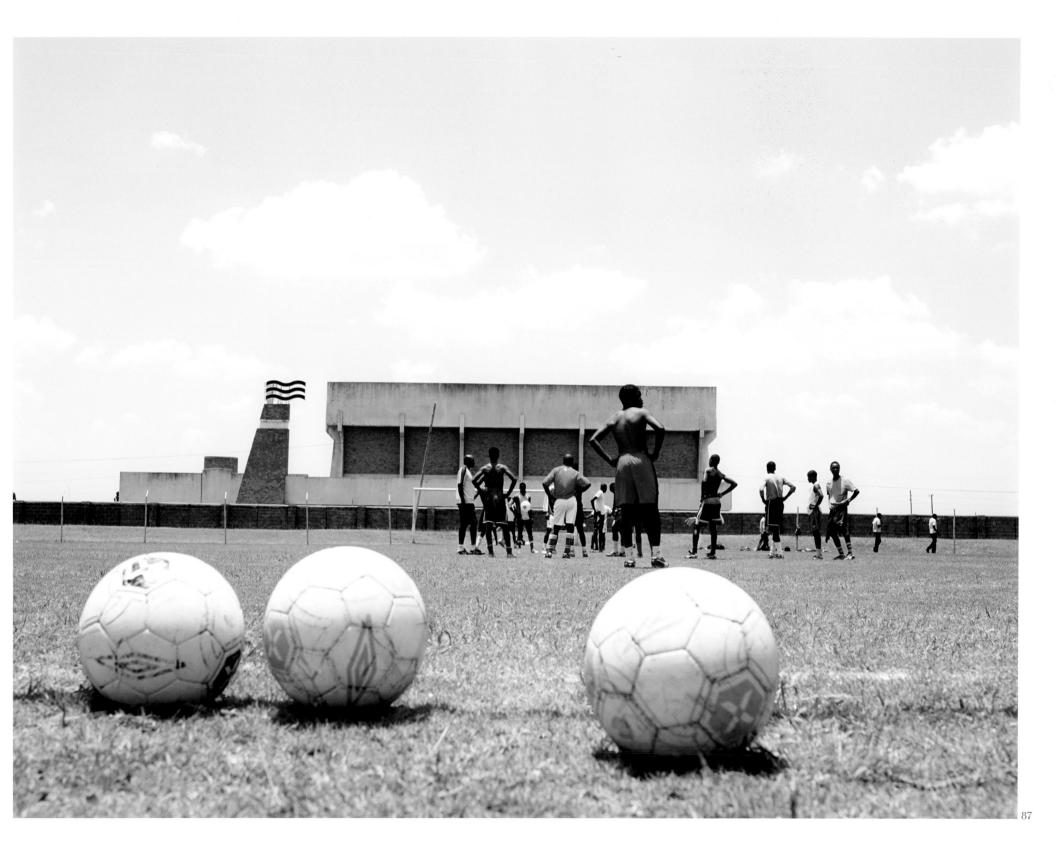

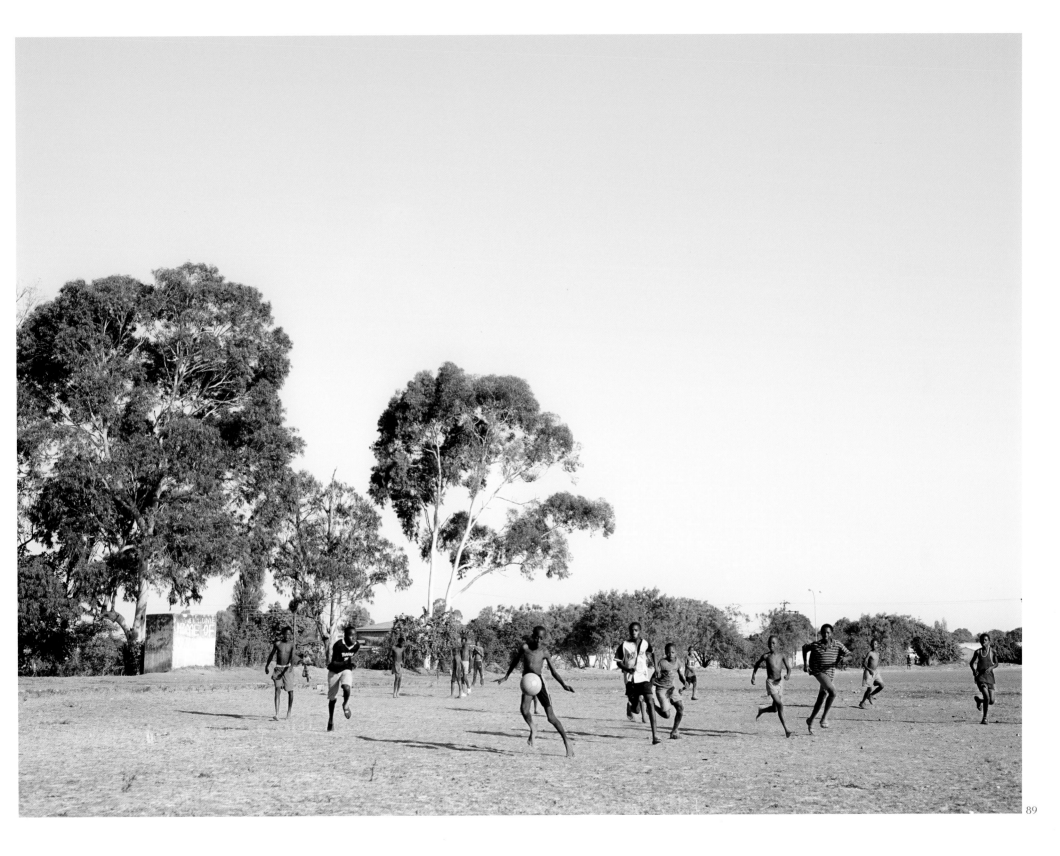

Gabon Disaster Memorial Site, behind Independence Stadium, Lusaka, Zambia, 2007

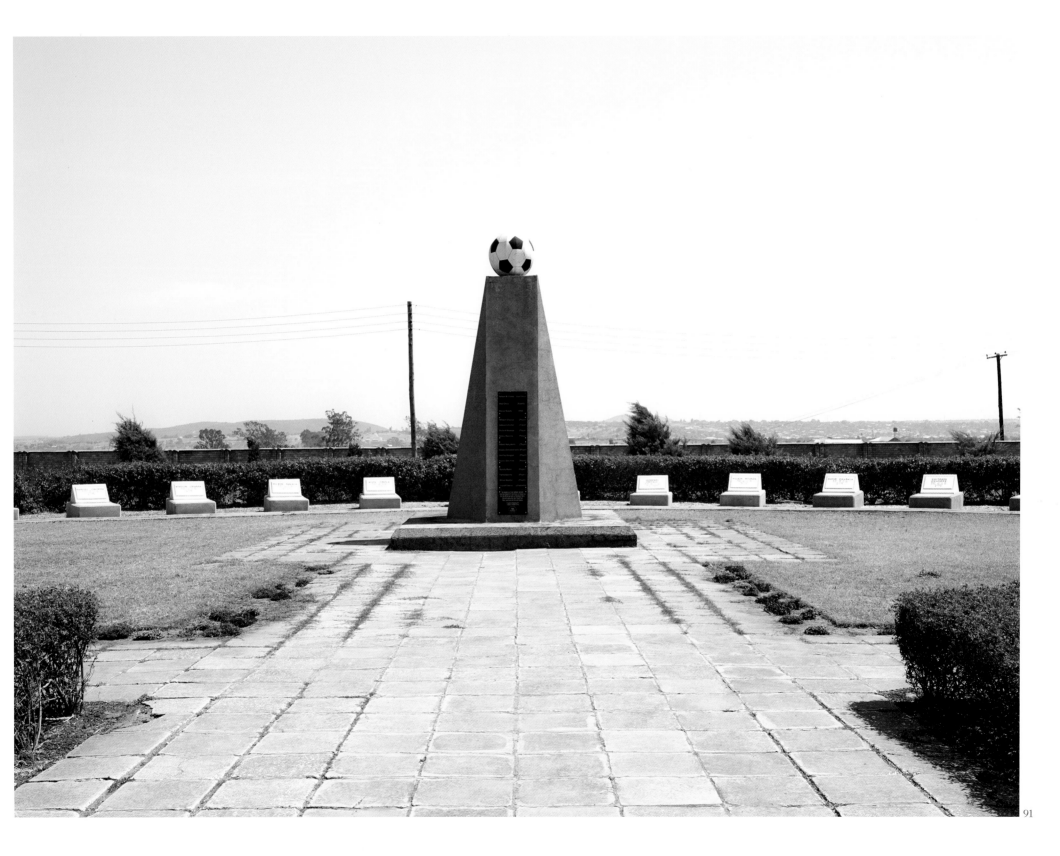

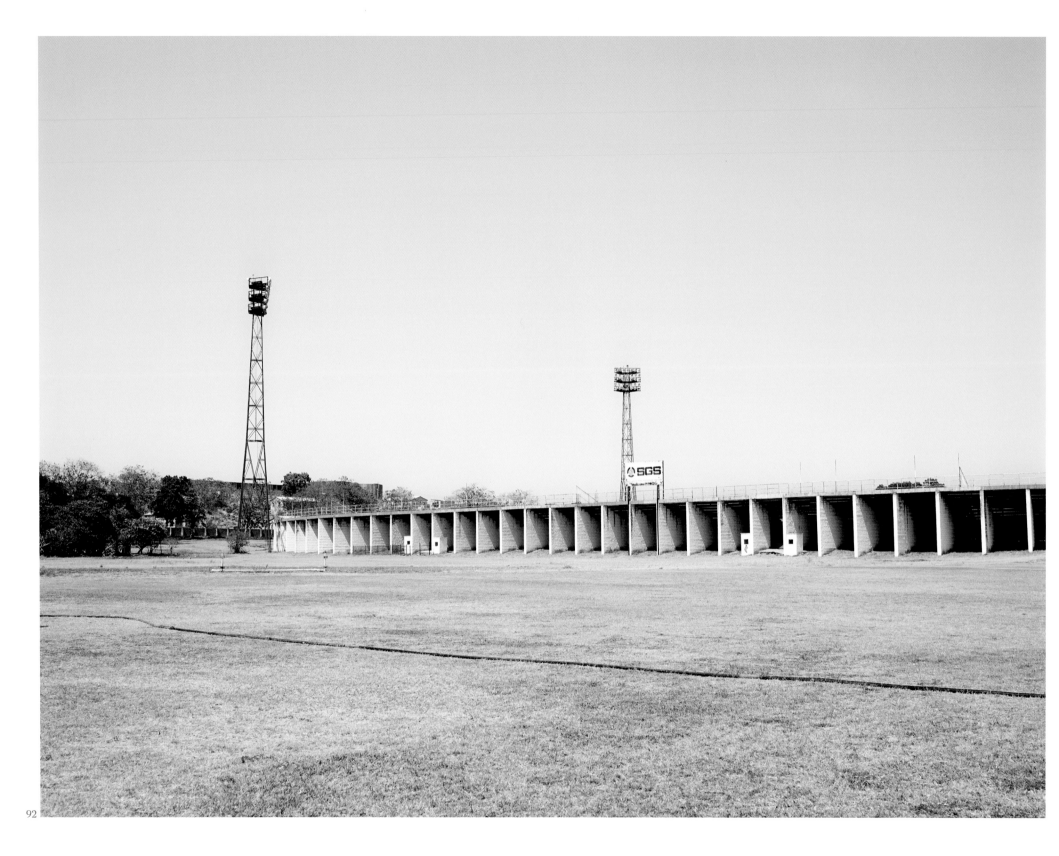

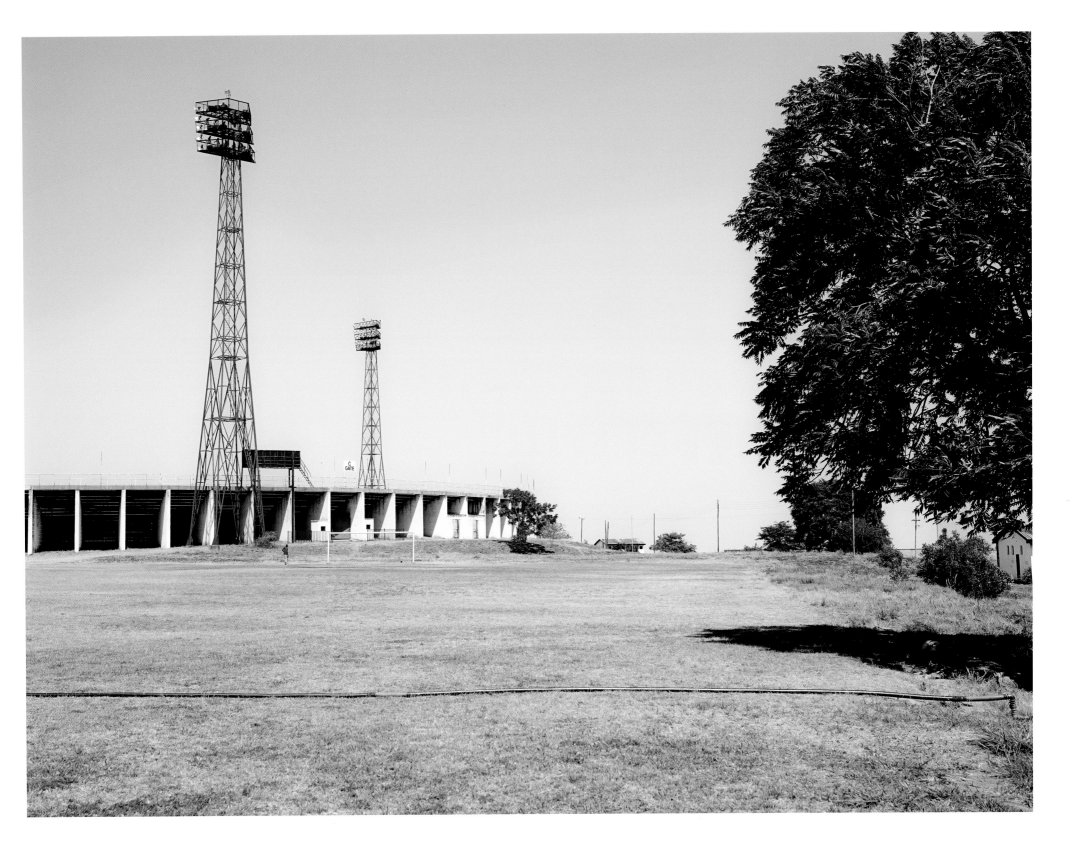

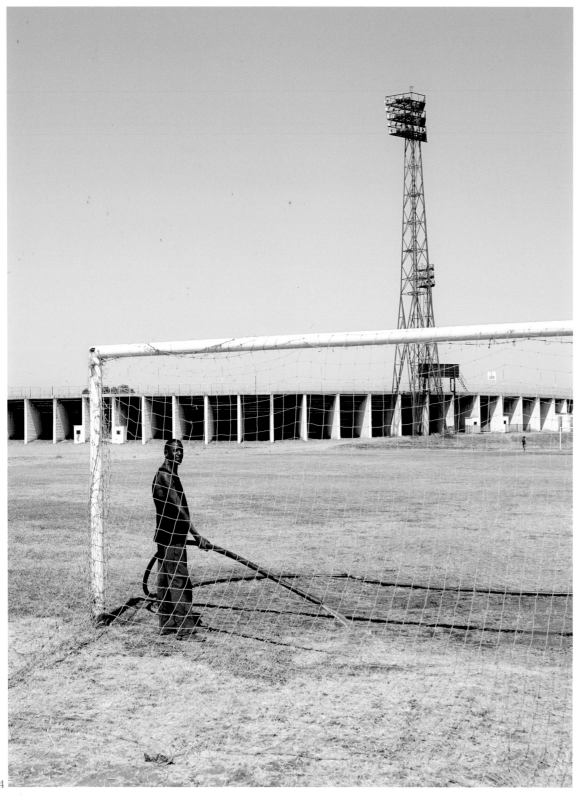

94

Pages 92–94: Independence Stadium, Lusaka, Zambia, 2007

Players from Green Buffaloes F.C., Independence Stadium, Lusaka, Zambia, 2007

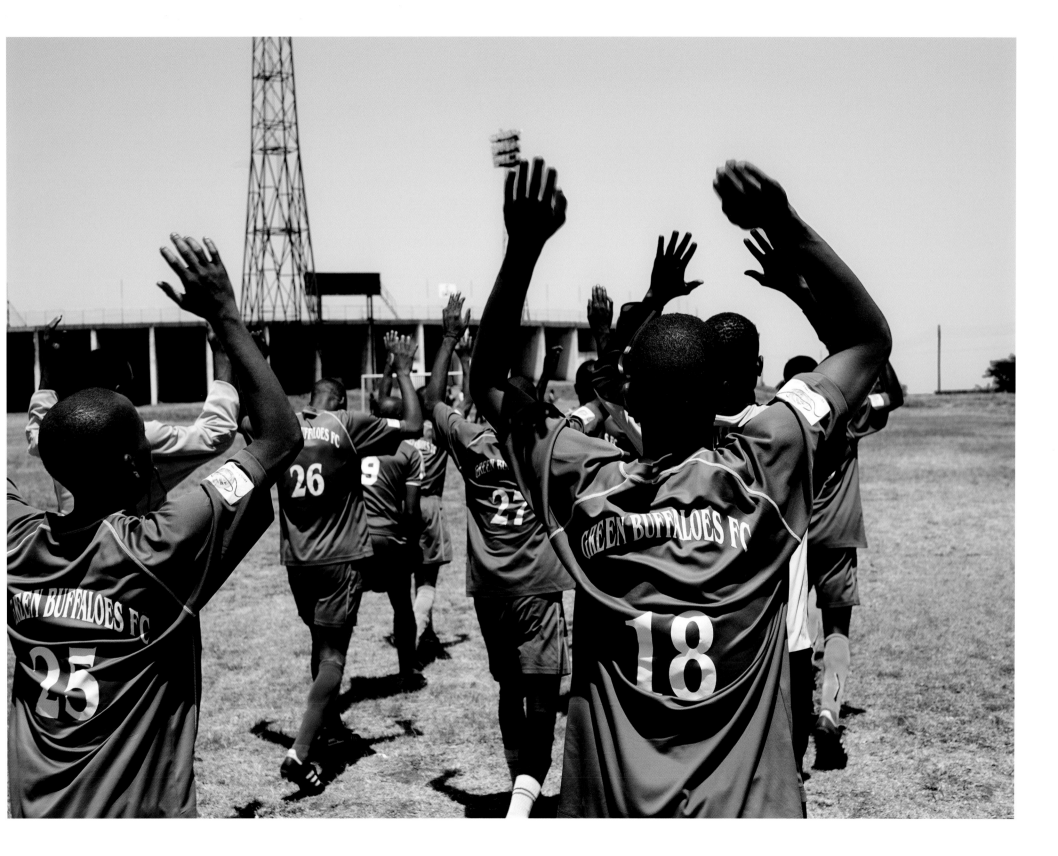

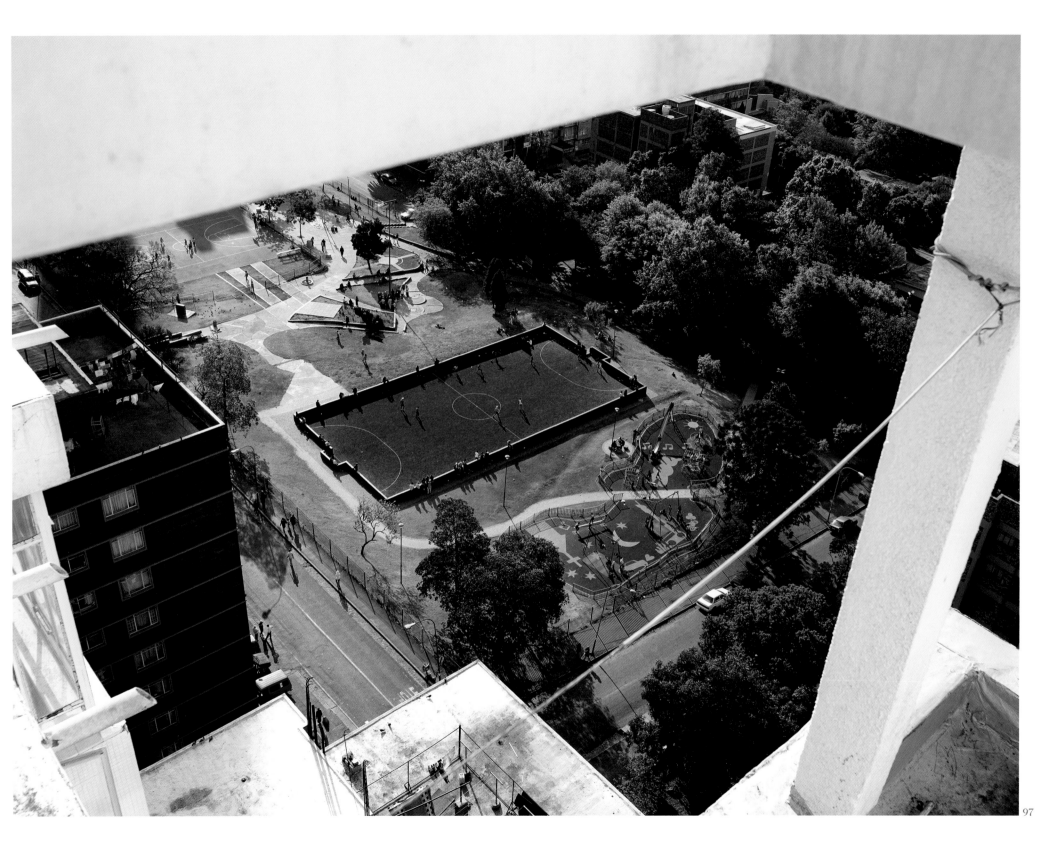

Independence Stadium, Windhoek, Namibia, 2007

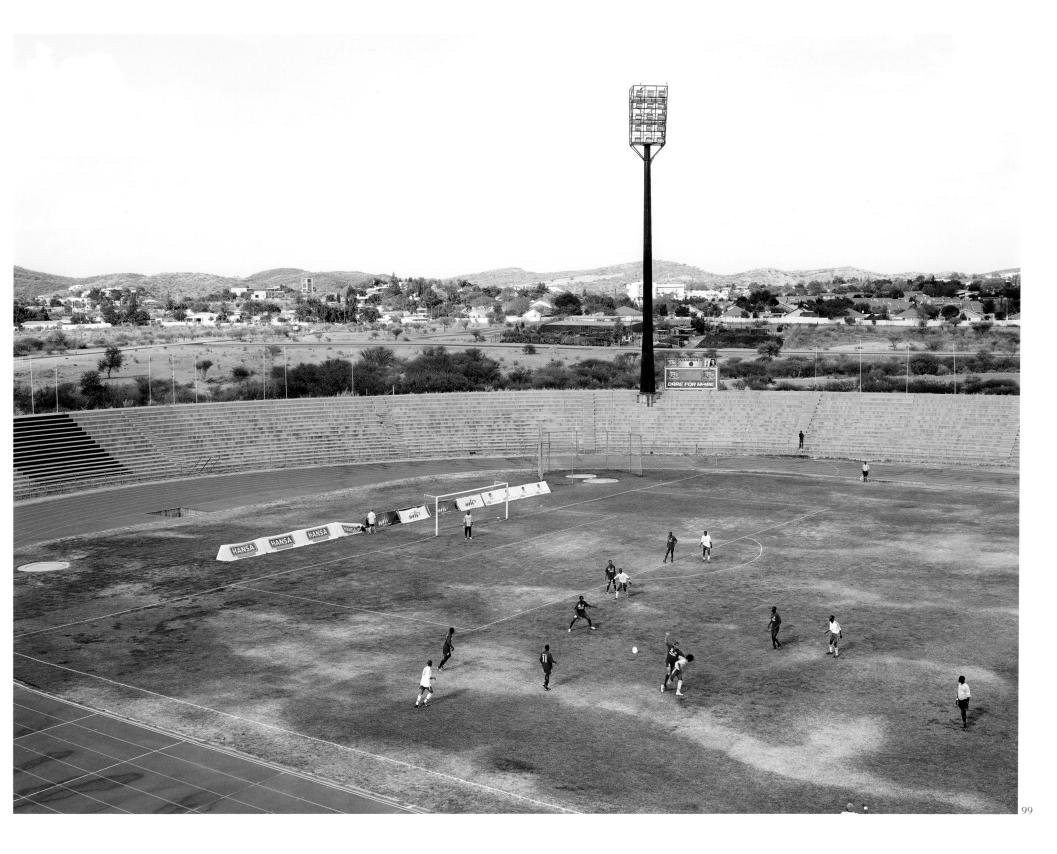

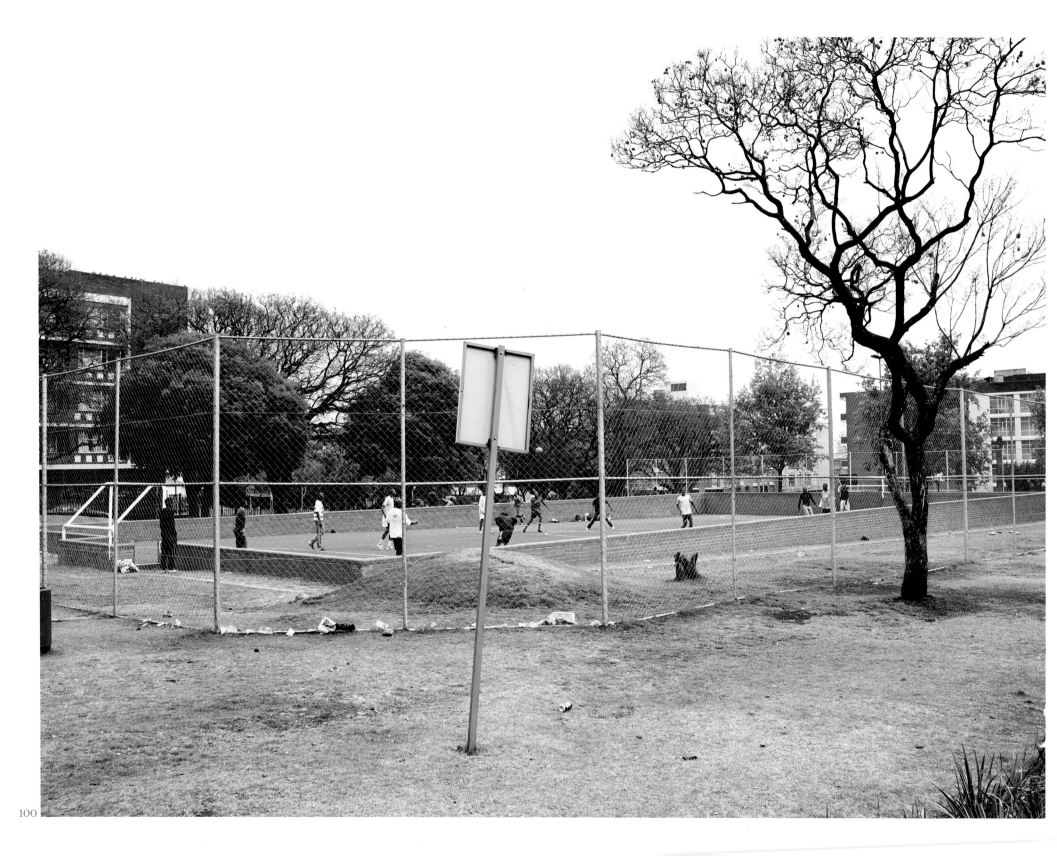

Berea Park, Johannesburg, South Africa, 2009

Queensmead Stadium, Lusaka, Zambia, 2007

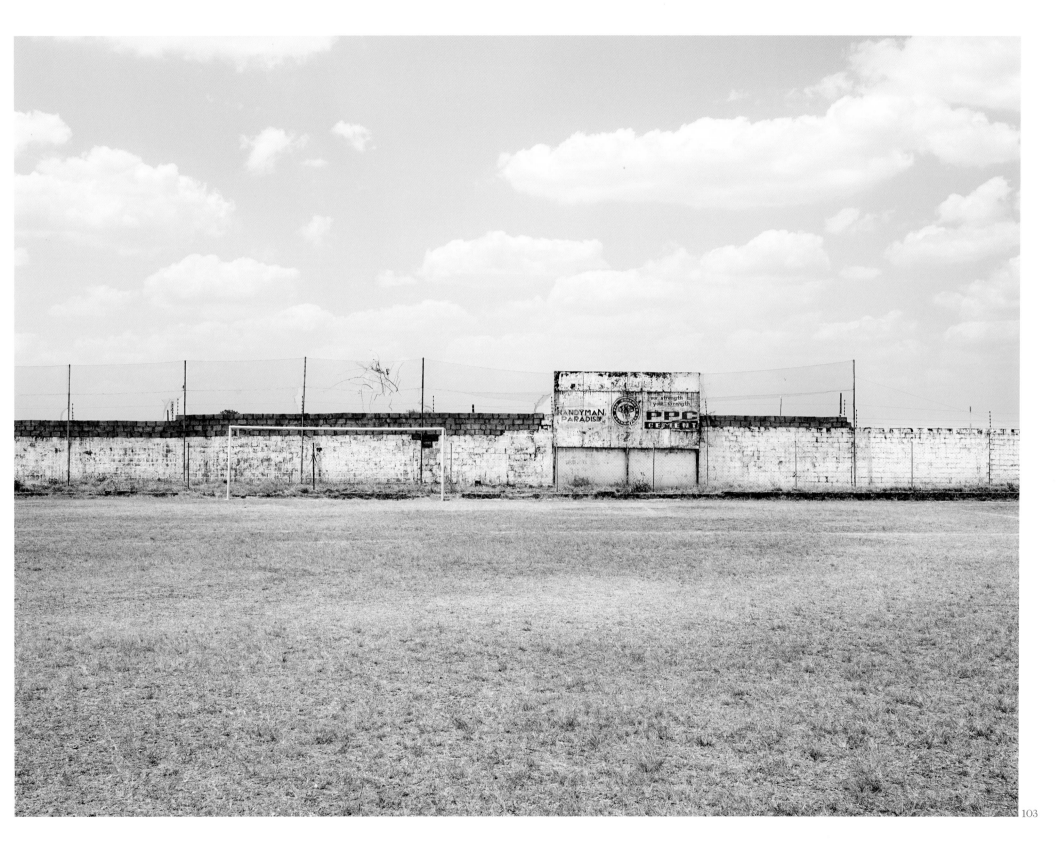

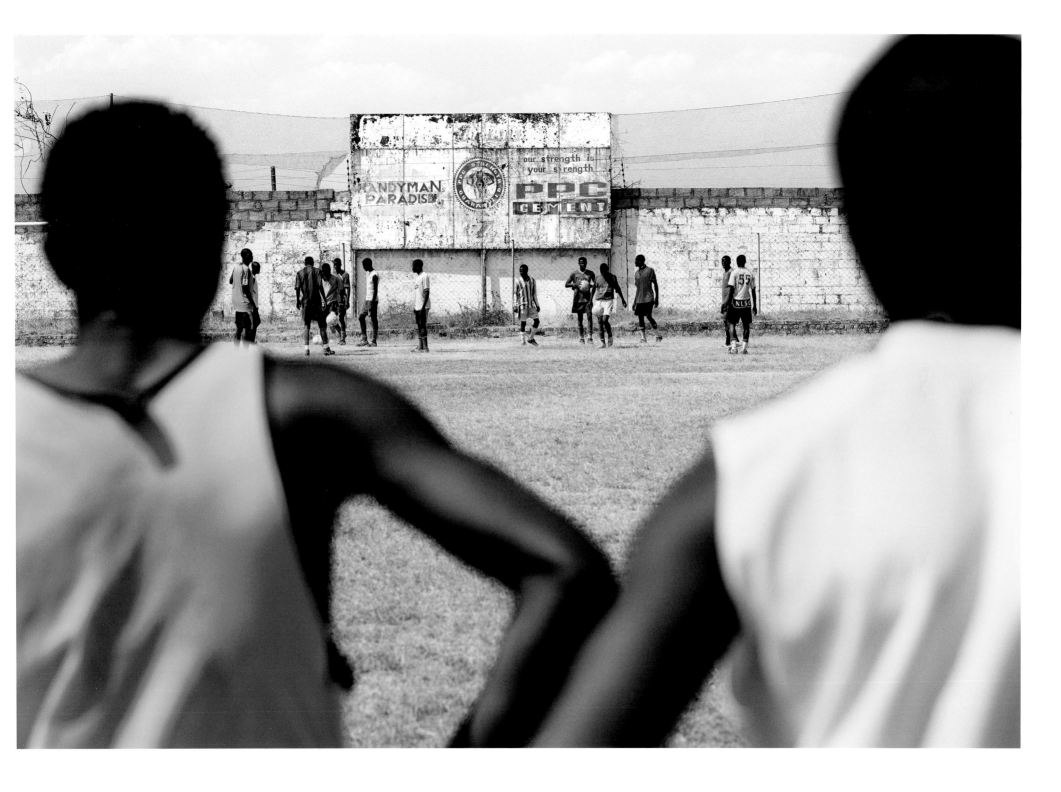

Queensmead Stadium, Lusaka, Zambia, 2007

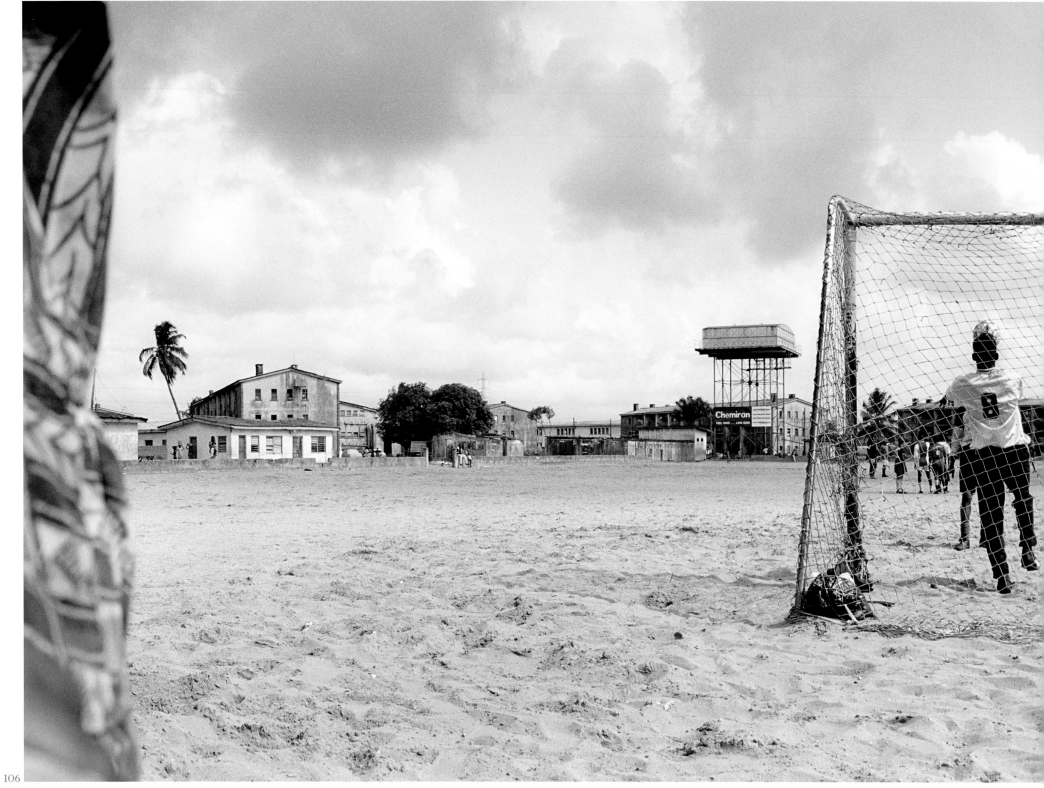

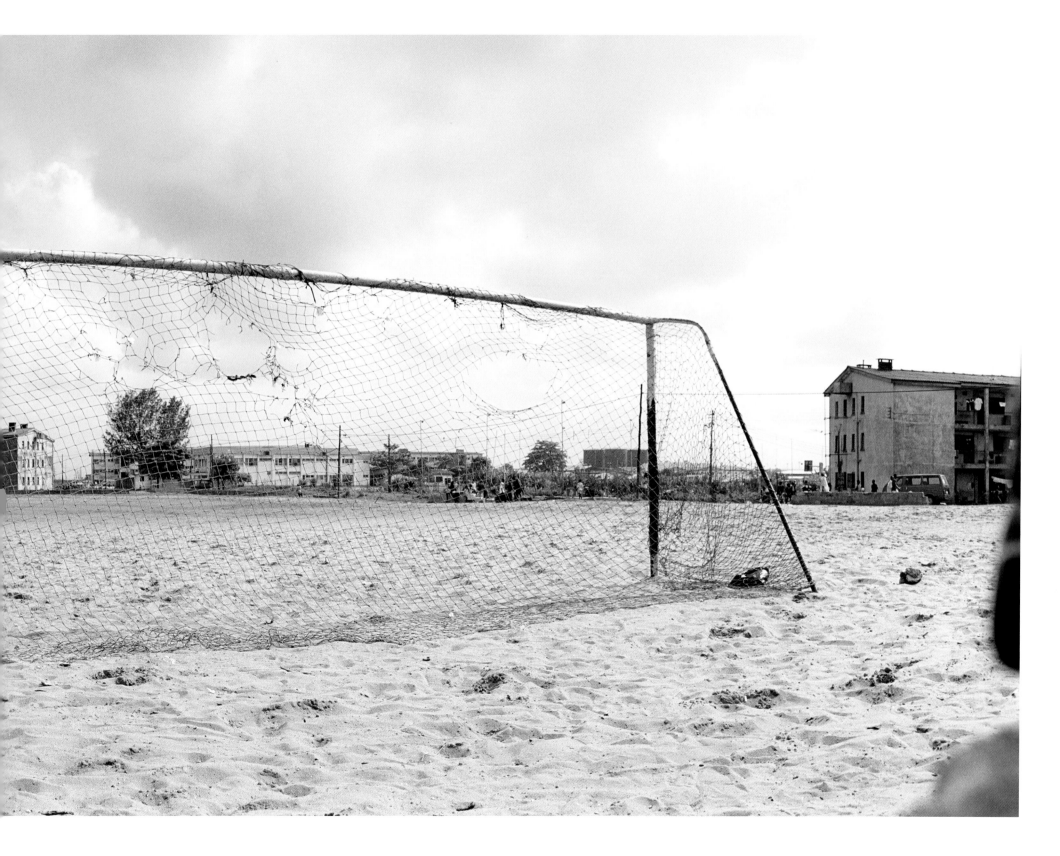

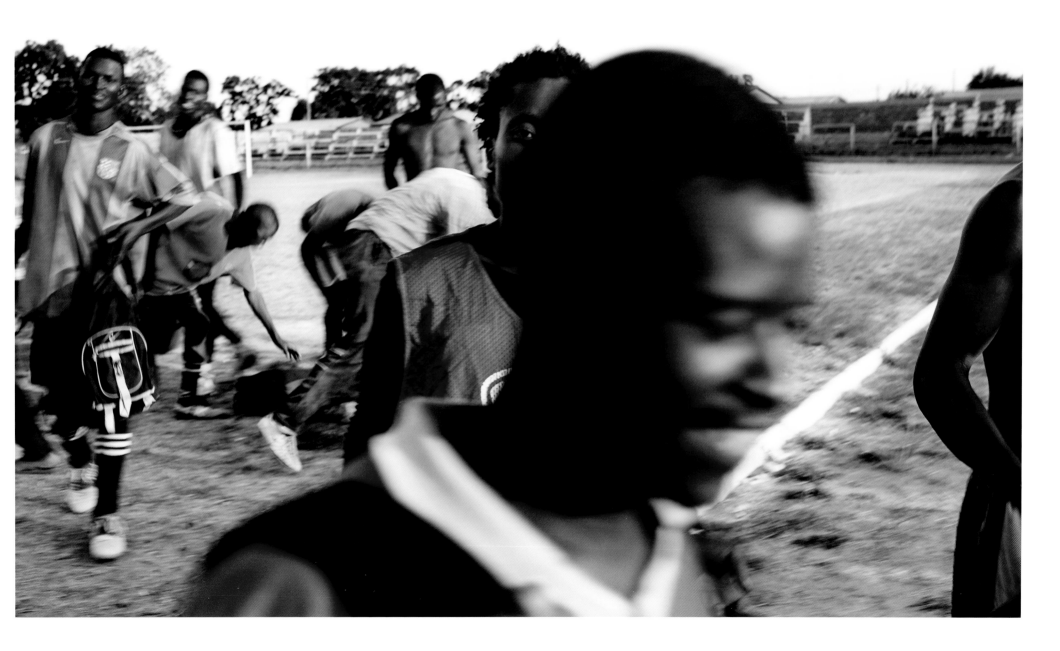

Pages 106 & 107: Lagos, Nigeria, 1999

Onikan Stadium, Lagos, Nigeria, 2007

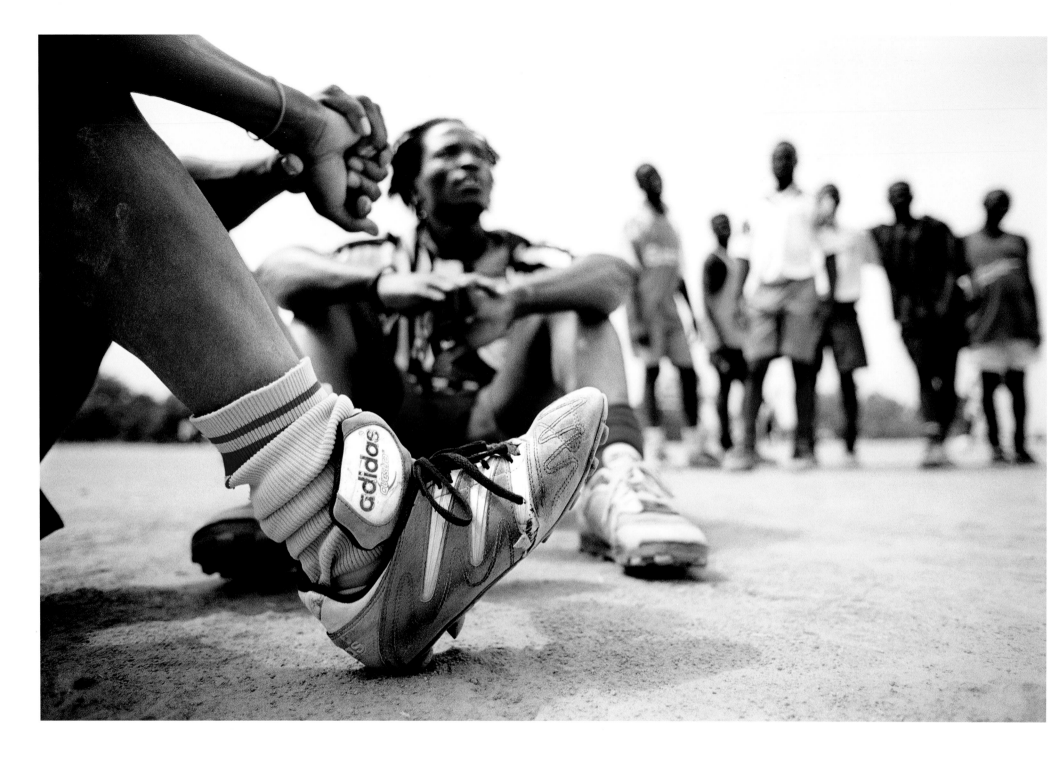

Abuja, Nigeria, 1999

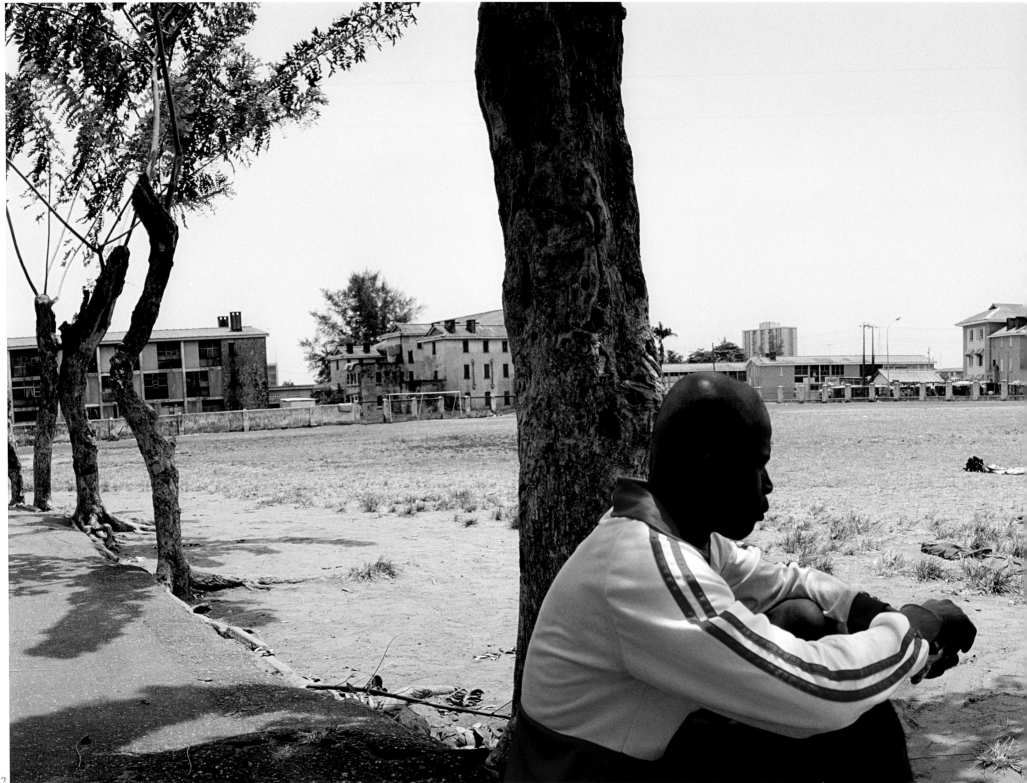

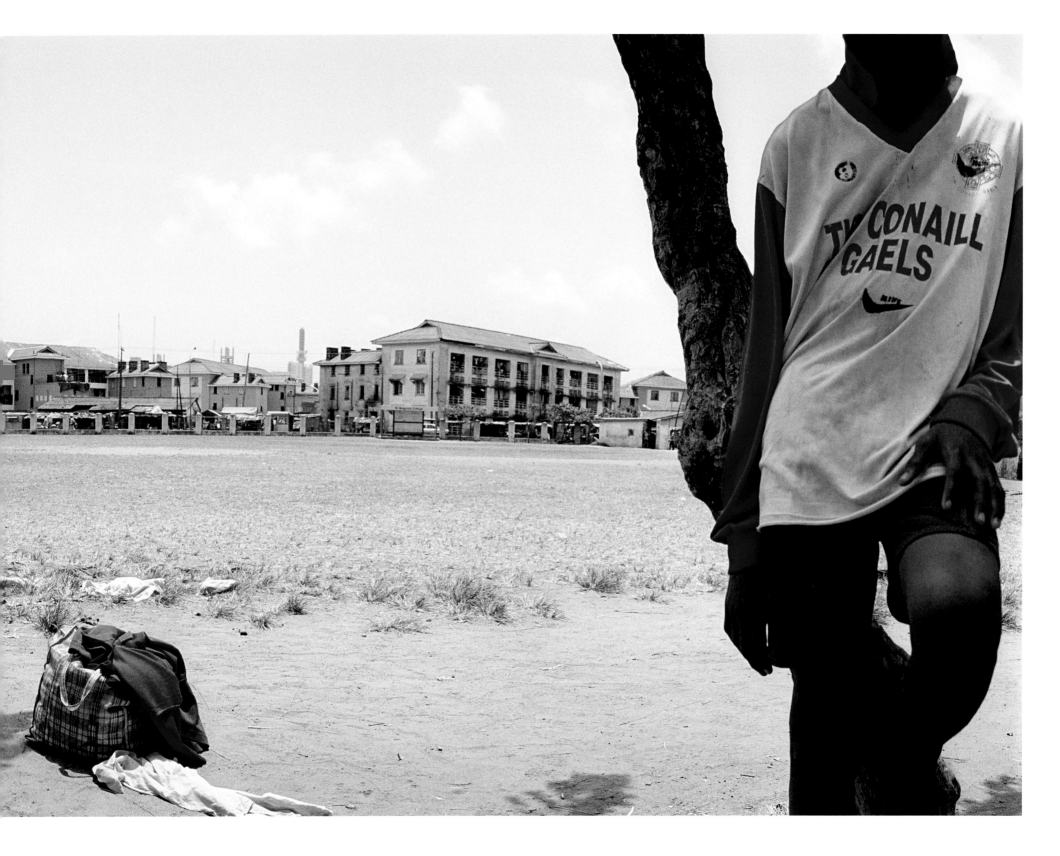

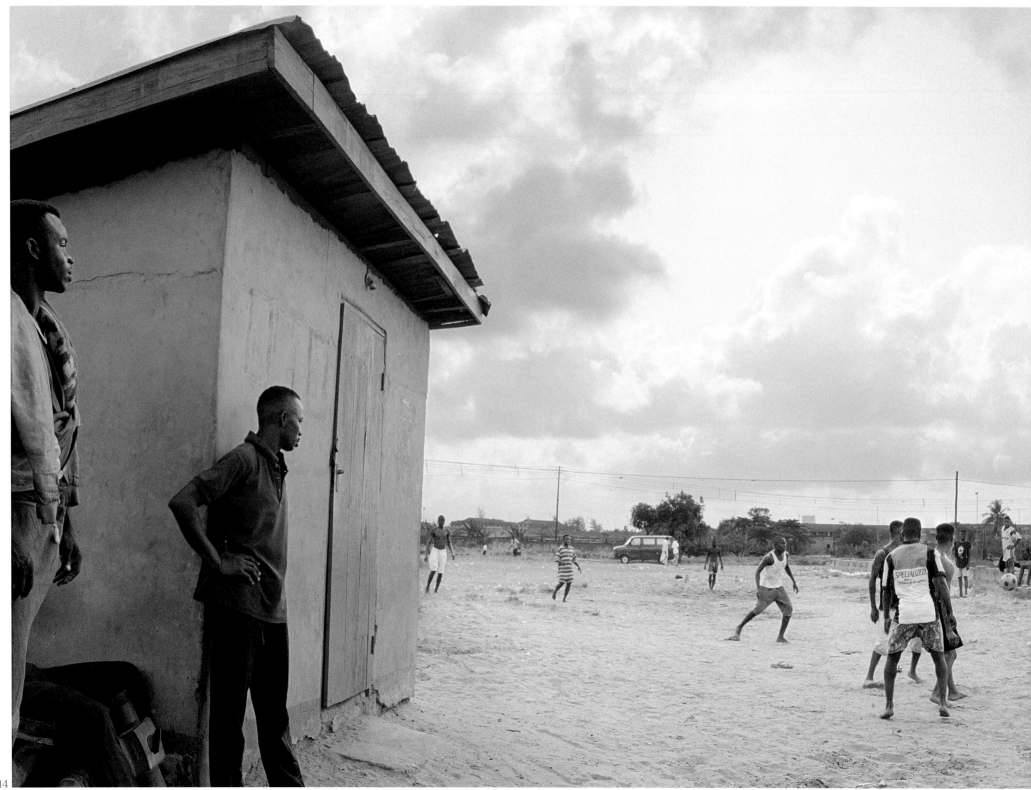

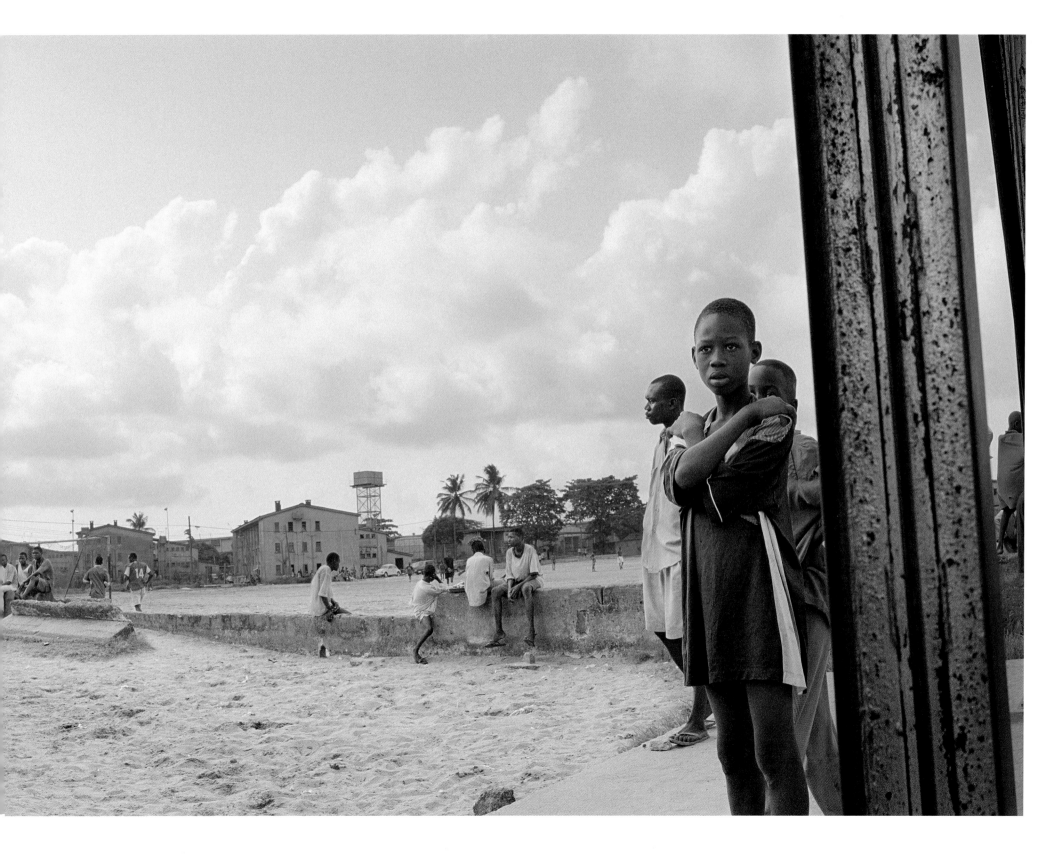

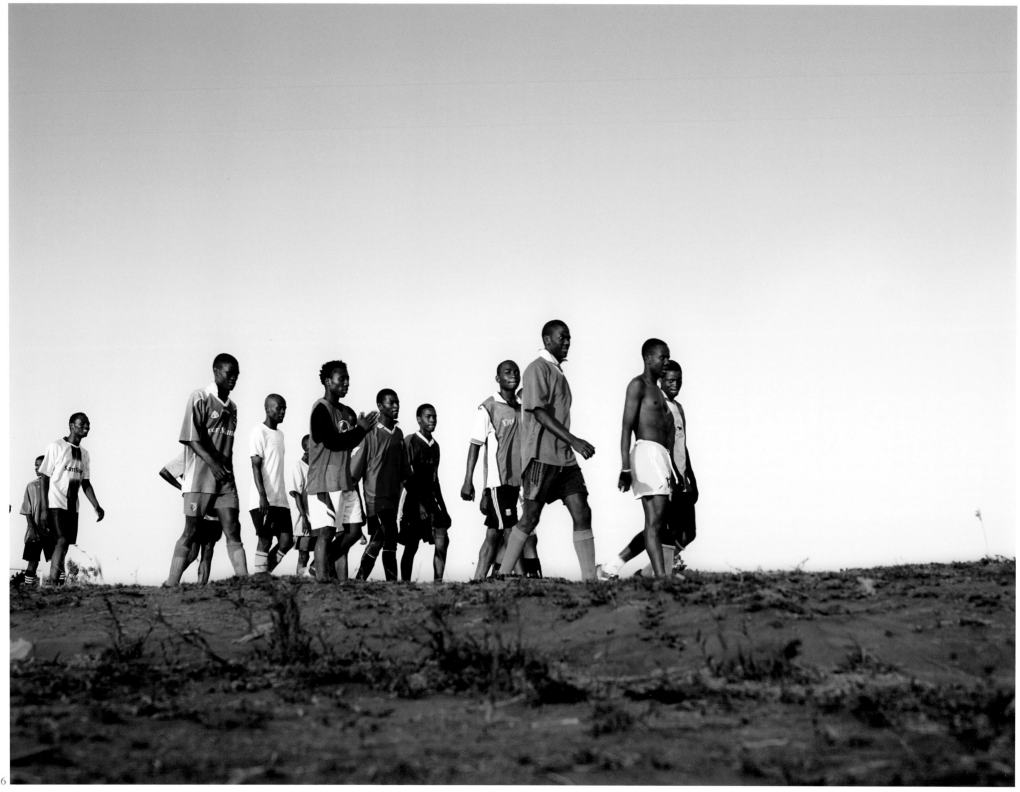

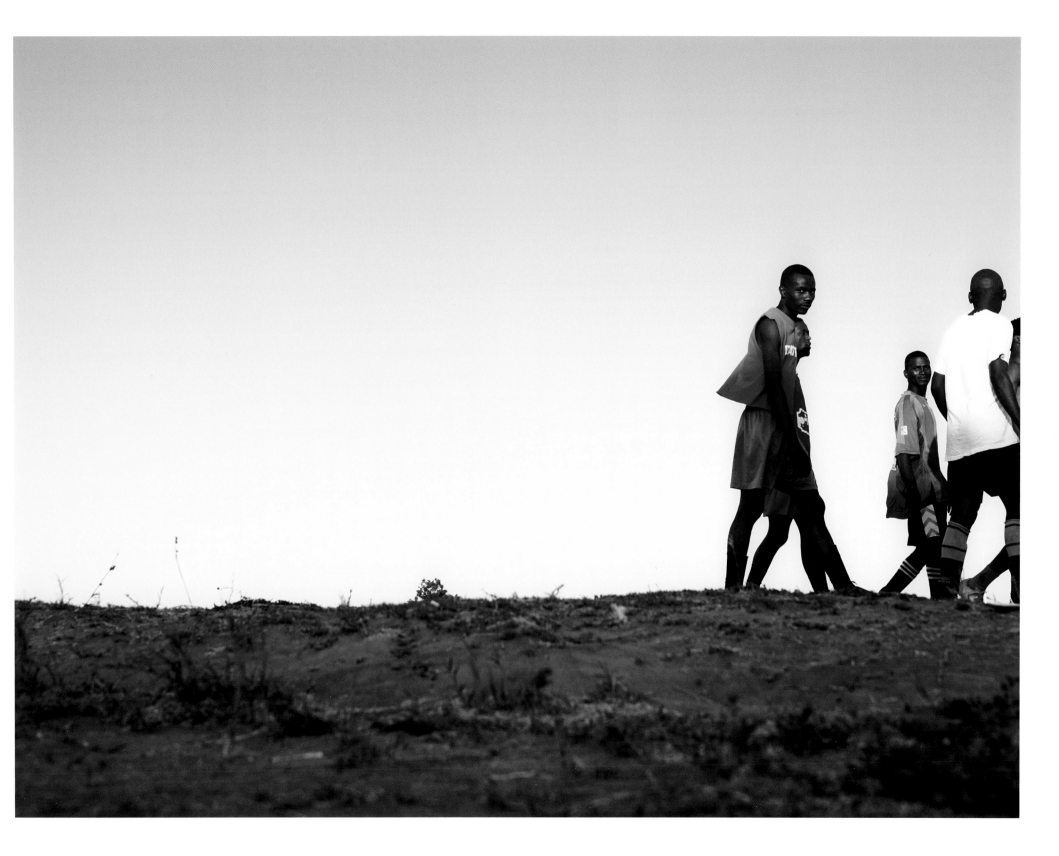

Pages 112–115: Lagos, Nigeria, 1999
Pages 116 & 117: Queensmead Stadium, Lusaka, Zambia, 2007

Hillbrow, Johannesburg, South Africa, 2009

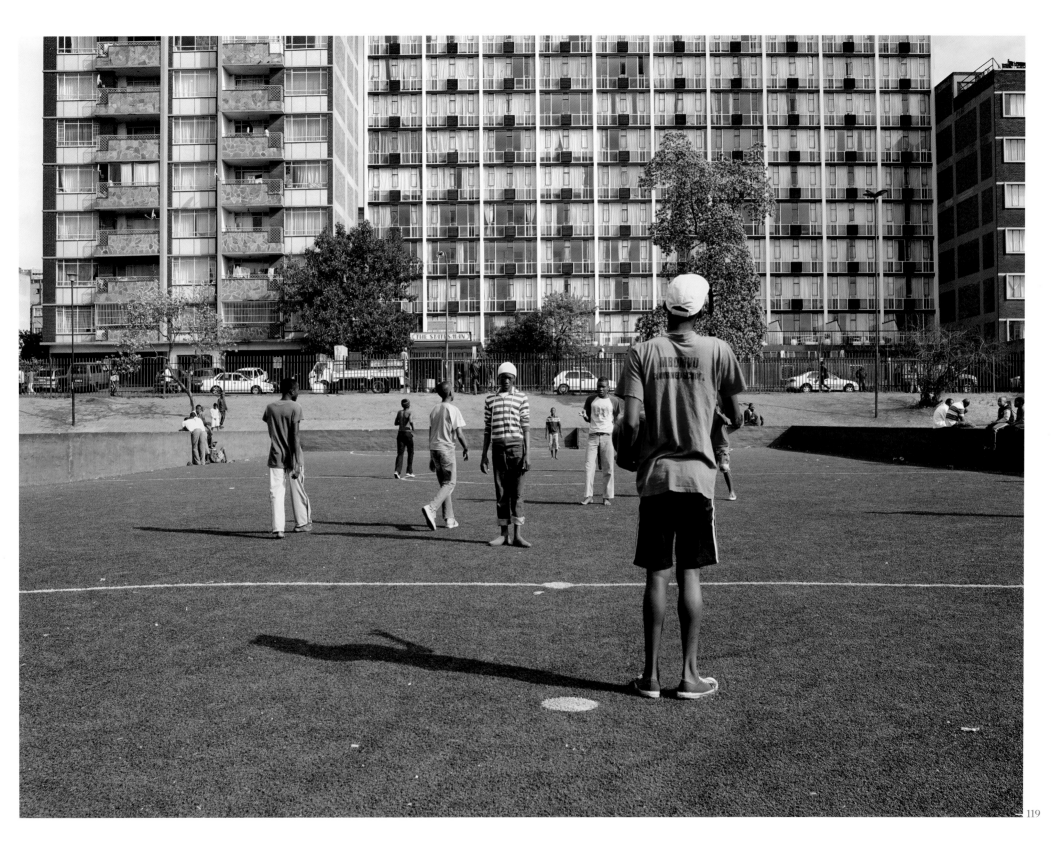

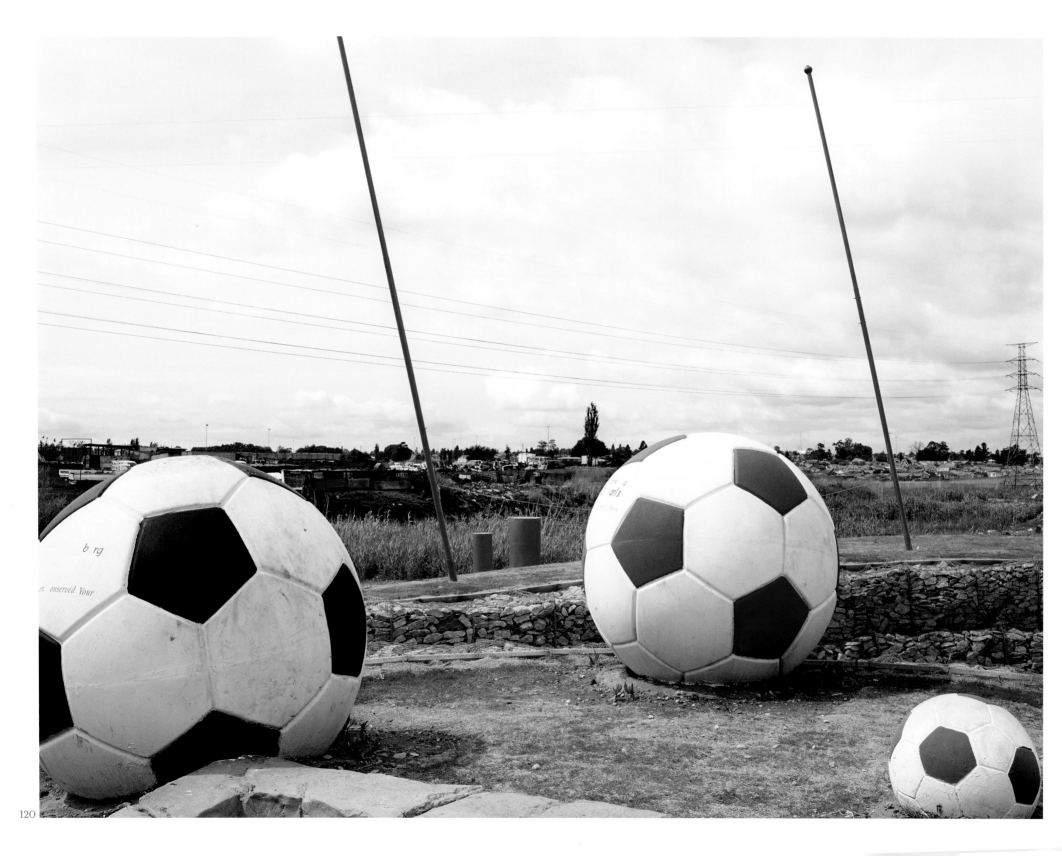

Soweto, Johannesburg, South Africa, 2009

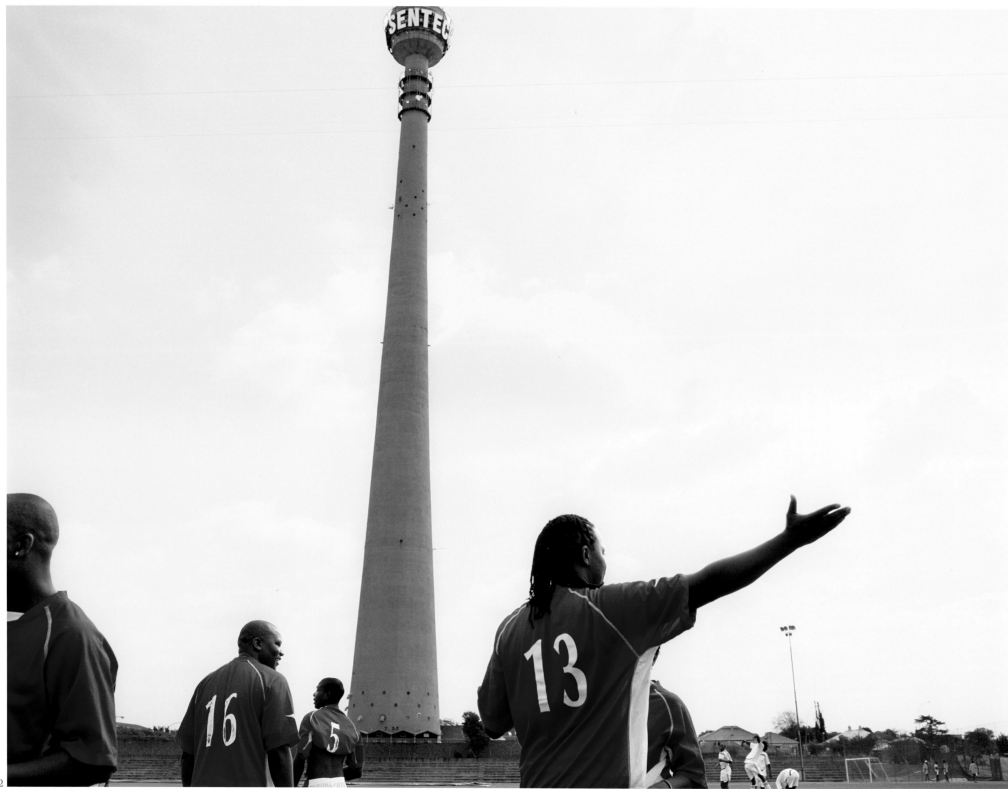

UJ Stadium, Johannesburg, South Africa, 2009

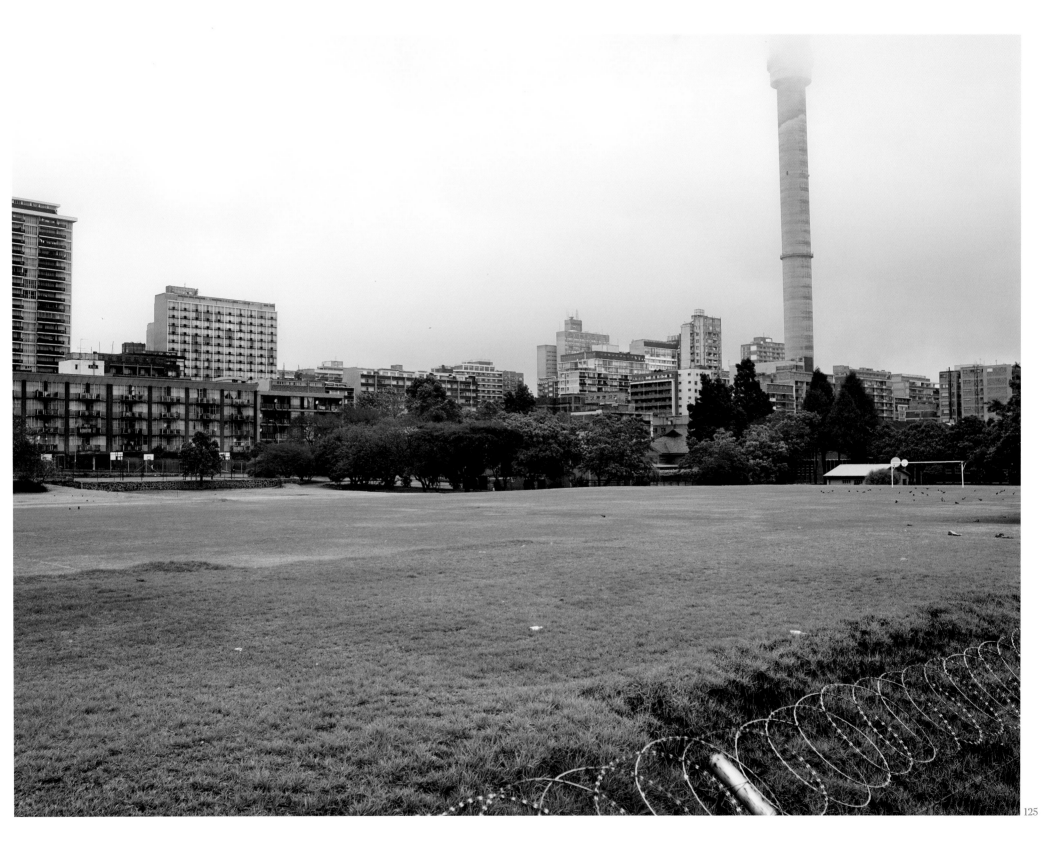

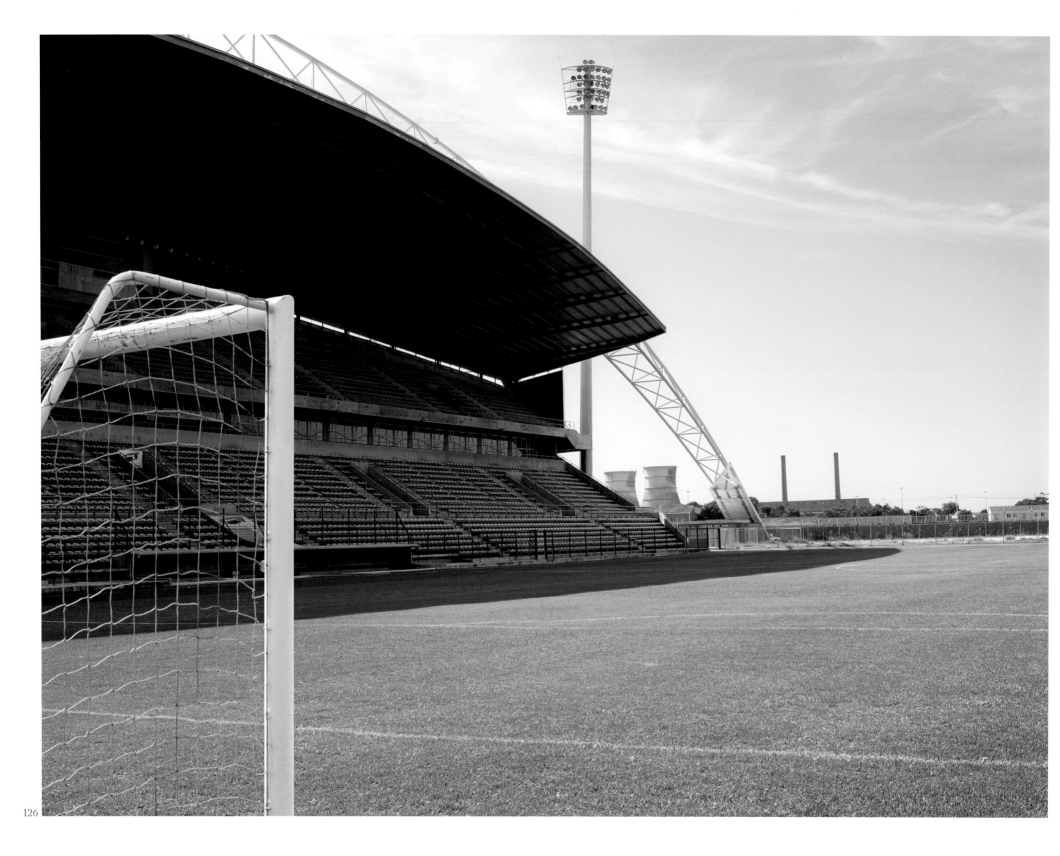

Athlone Stadium, Cape Town, South Africa, 2006

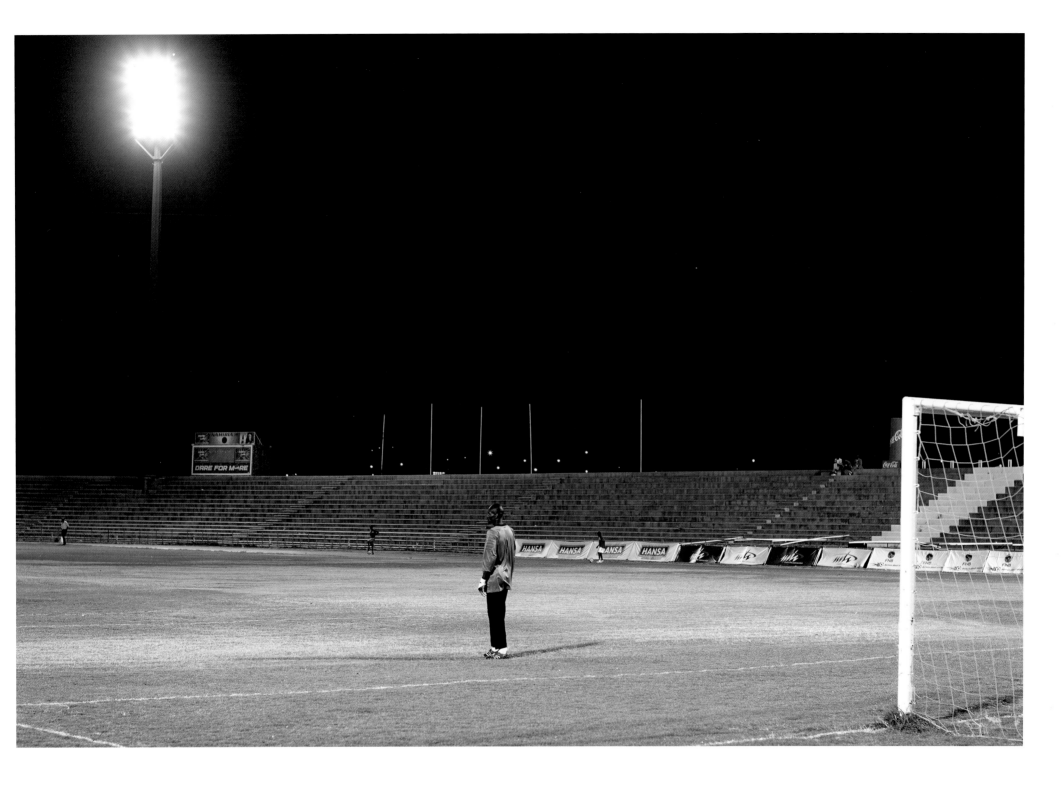

Independence Stadium, Windhoek, Namibia, 2007

Katutura, Namibia 2007

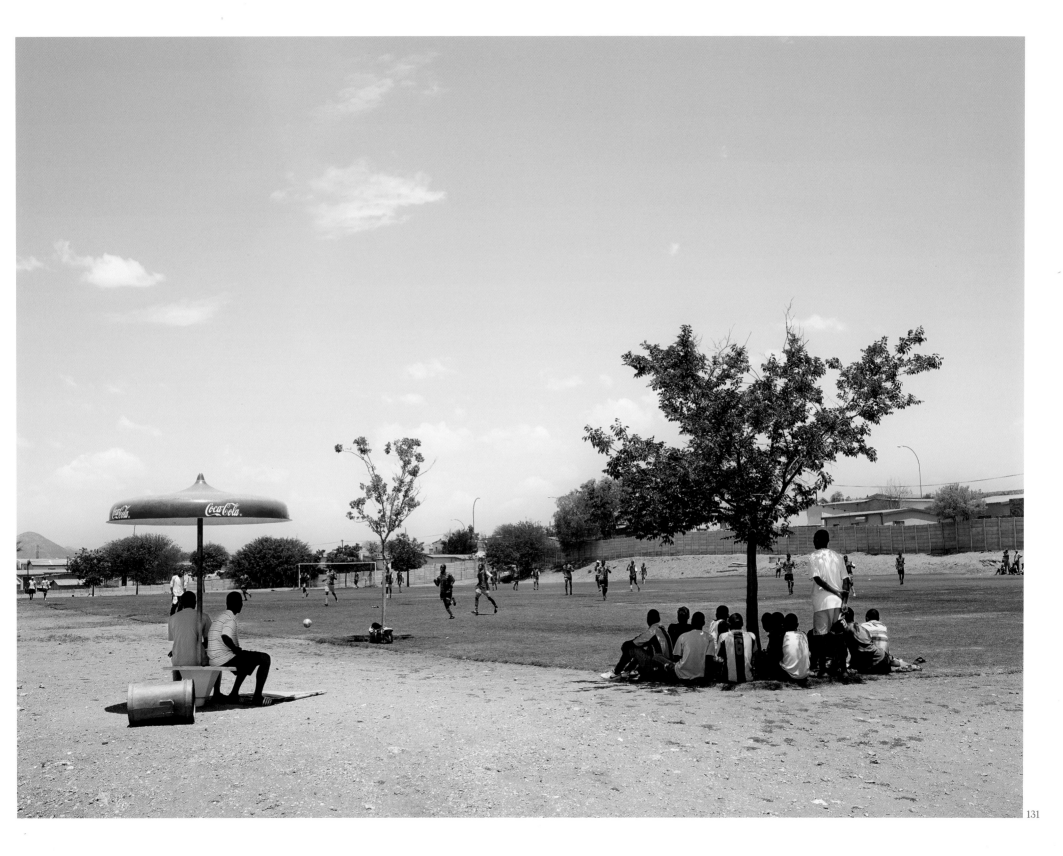

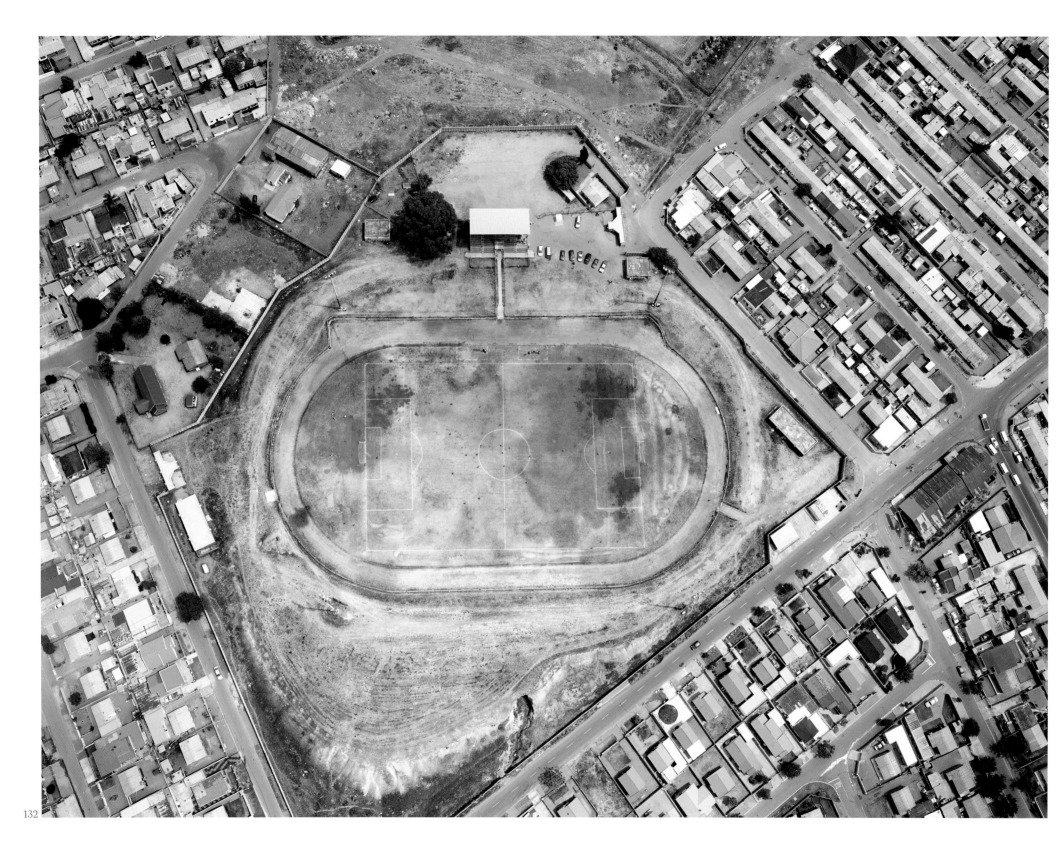

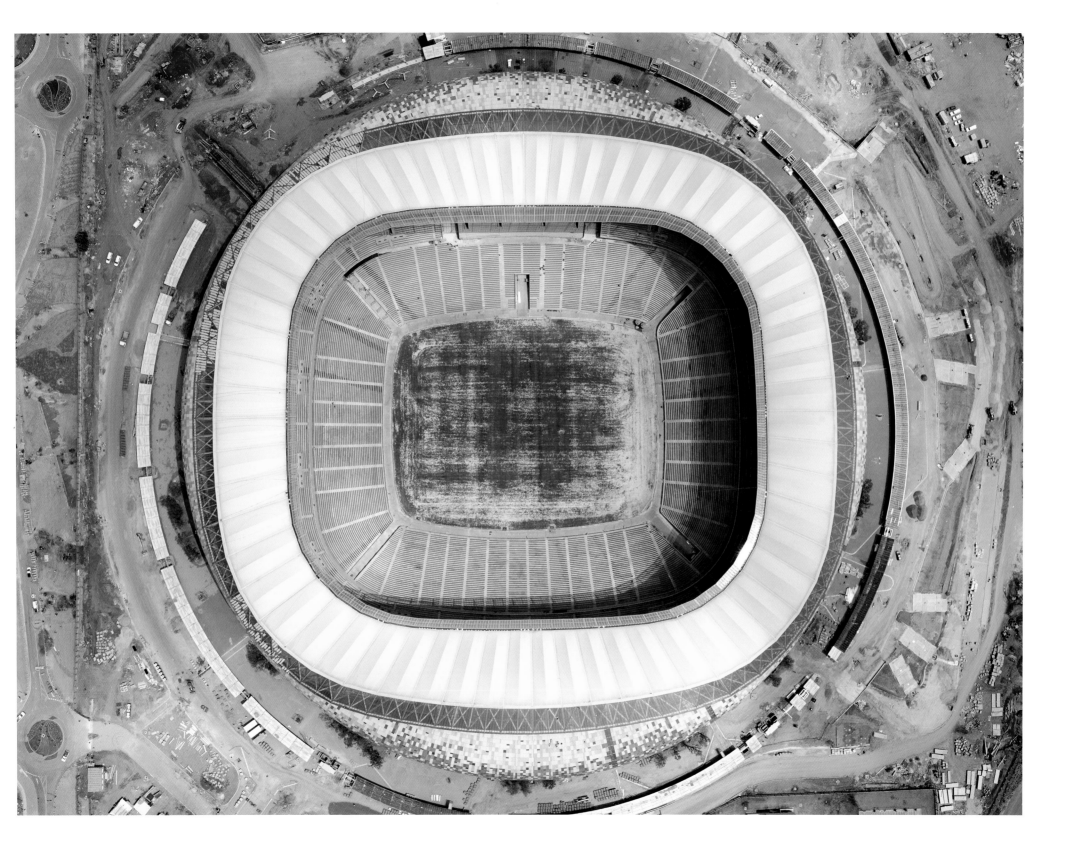

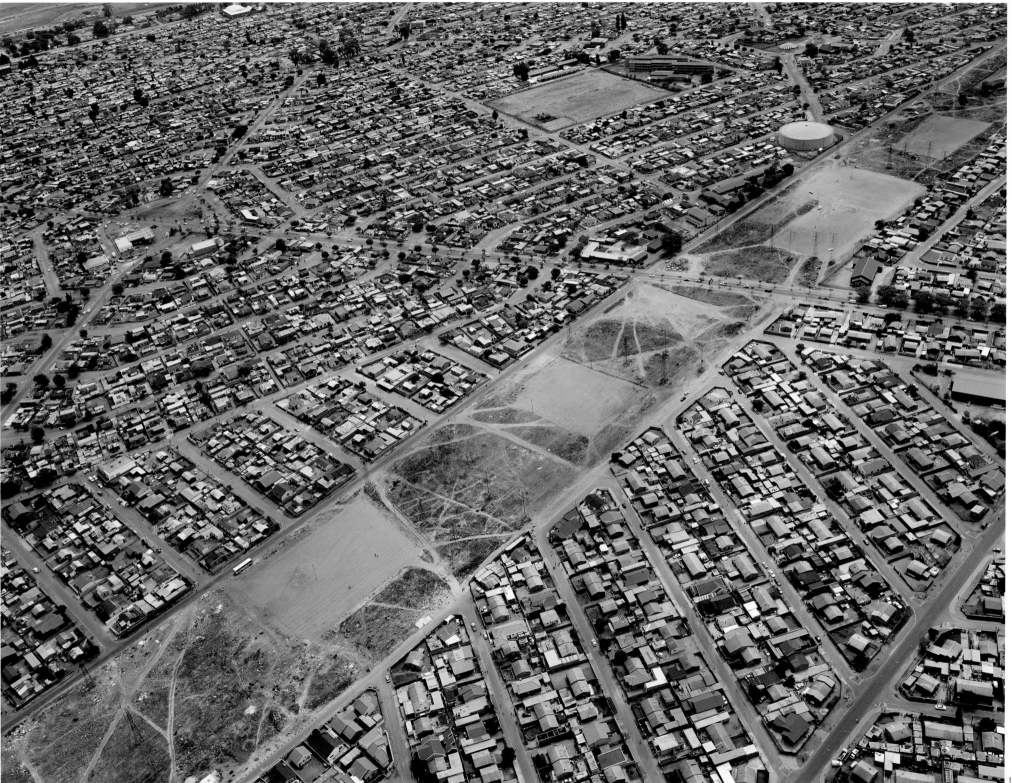

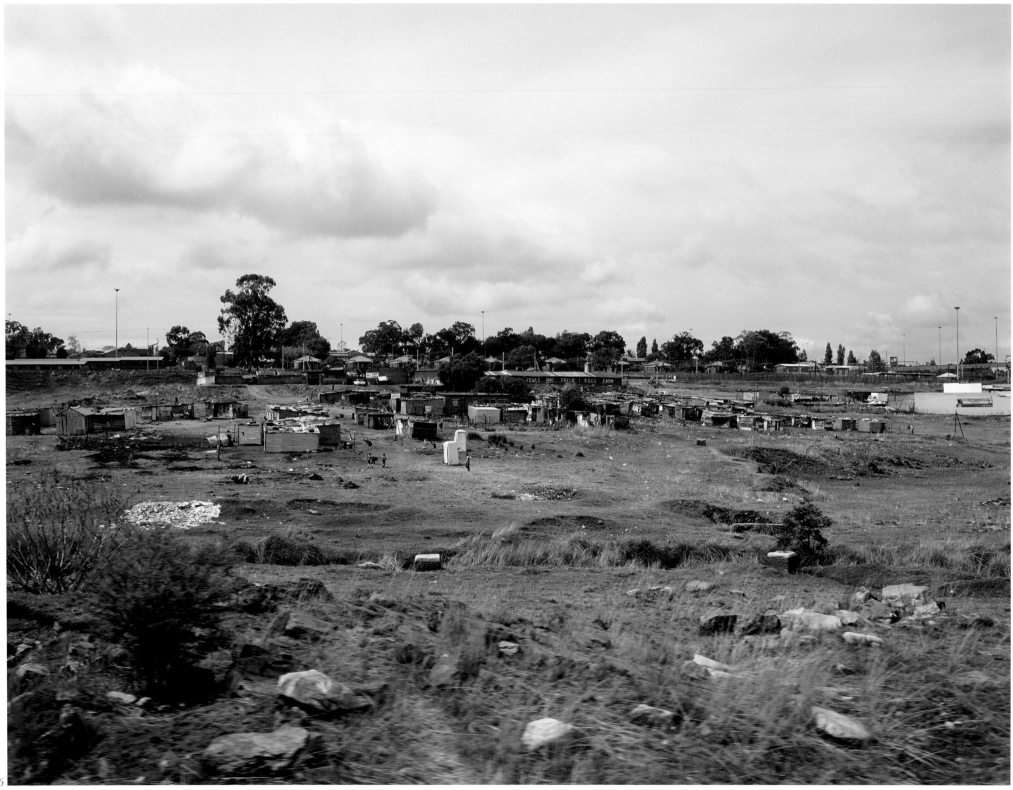

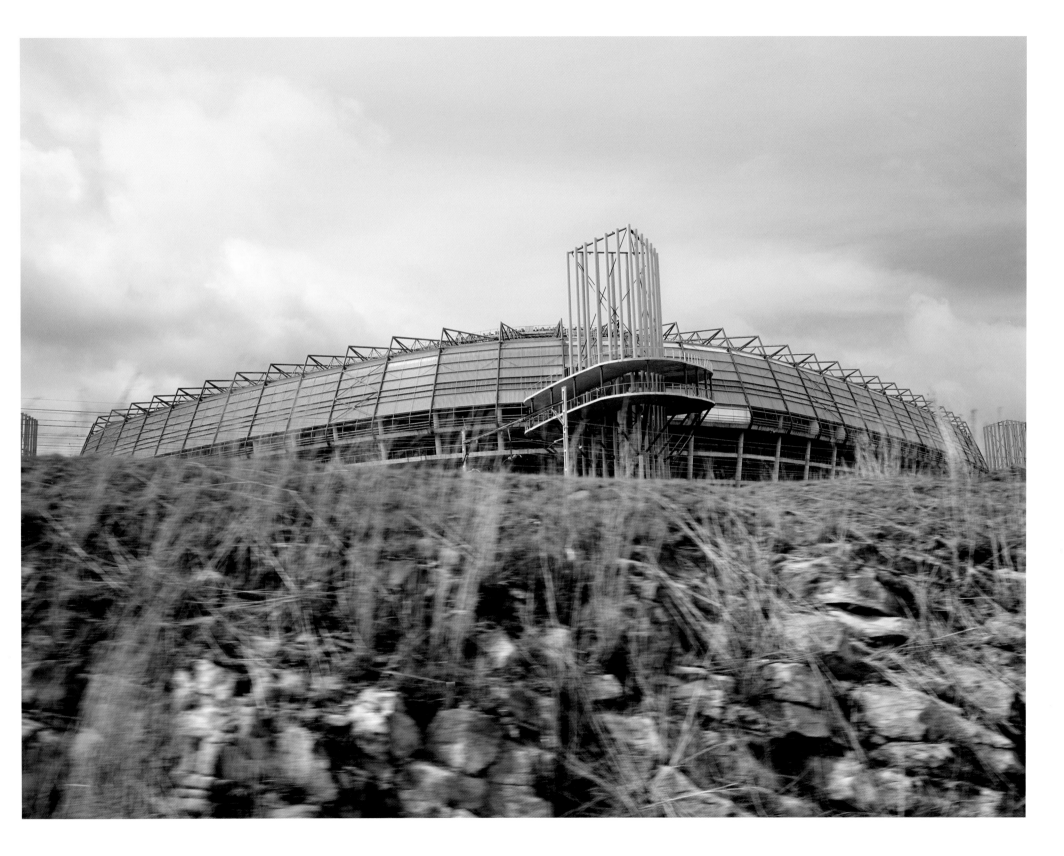

Page 136: Orlando, Johannesburg, South Africa, 2009
Page 137: Orlando Stadium, Johannesburg, South Africa, 2009

Sam Nujoma Stadium, Windhoek, Namibia, 2007

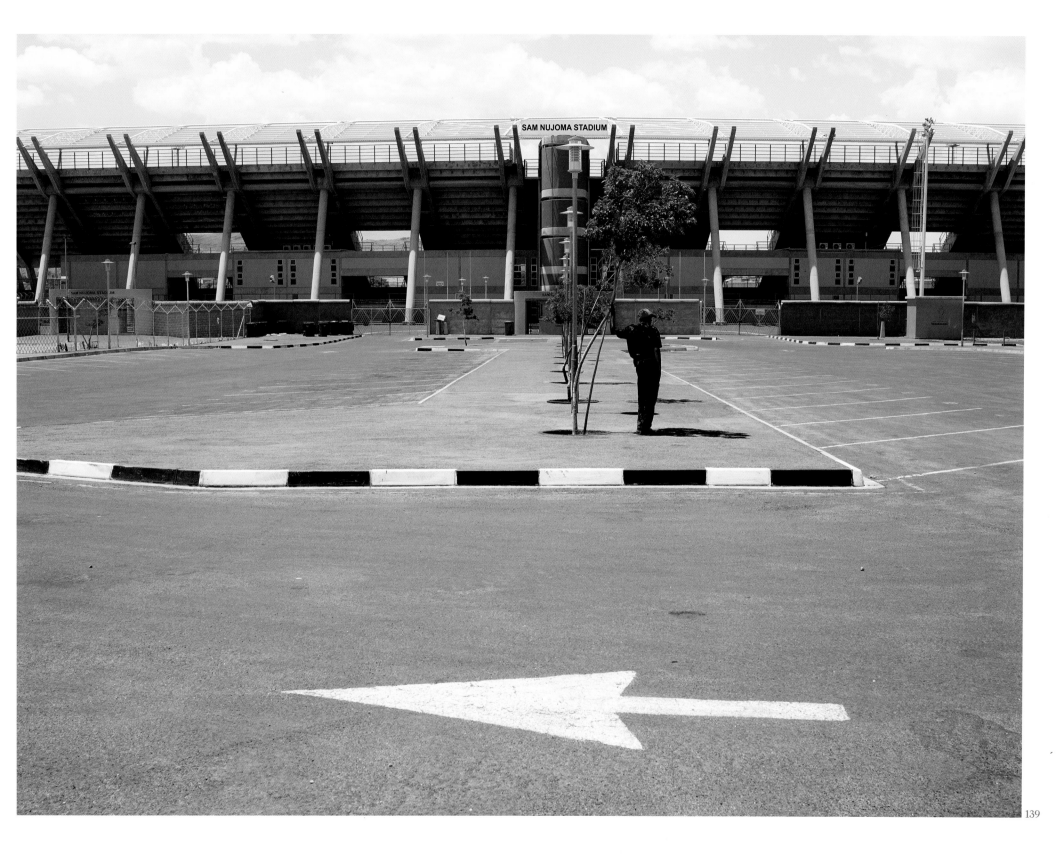

Athlone Stadium, Cape Town, South Africa, 2006

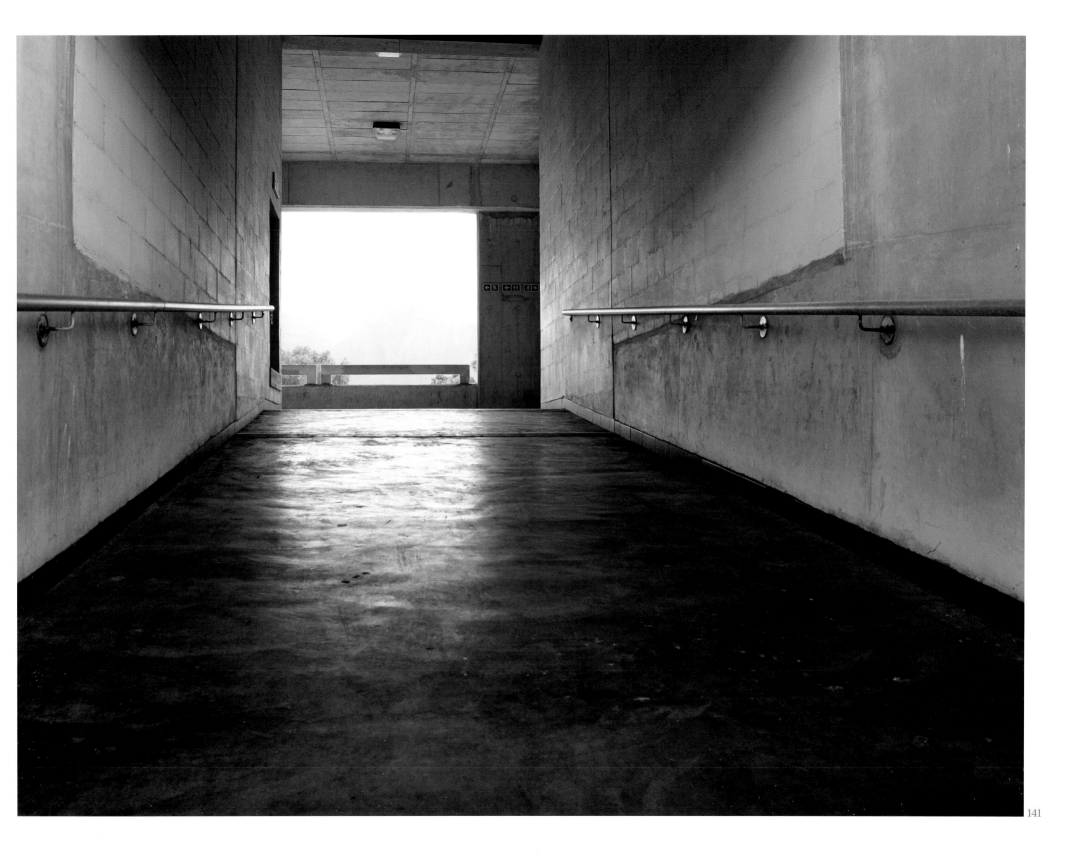

Biography
Biografie

Thomas Hoeffgen, born in Kiel, Germany, in 1968, fell in love with photography while sailing a yacht full of juvenile delinquents around the Canary Islands as part of his mandatory civic service (performed in lieu of military service). He tried to liven up the situation by shooting portraits of the kids, capturing immediate moments and also some of the passing scenery. This was the beginning of Thomas's spontaneous pictorial relationship with movement, foreshadowing his enduring ability to record fleeting moments in a reduced, minimalistic style.

After finishing his service he moved to Spain at the age of twenty to assist the Mallorca-based art photographer Elizabeth Schäufler. Even before completing photography school, Thomas began shooting for prestigious sports clients like Burton, Oxbow, and O'Neill, travelling all over the world to photograph for their advertising campaigns and capture their athletes on camera.

This early work brought him into contact with fashion and advertising clients such as G-Shock, Renault, O'Neill, Diesel, Maybelline, Escada, Laurel, Adidas, Microsoft, BMW, Swatch, Audi, Red Bull, and Camel Active all of whom were attracted by Thomas's laid-back, carefree style and by his energy and graphic simplicity.

His work has been published in magazines such as *Stern, SZ-Magazin, Instyle, Glamour, Elle, Marie Claire, B&W Magazine, Anglomania, Wallpaper,* and *Outside Magazine.* He has exhibited in Hamburg (Dormoolen), Duesseldorf (NRW-Forum), Munich (Goldberg Studio), Salem (Schloss Salem), Grasten (Atelier Corn Benniksgaard), Lisbon (Canon Gallery), Brooklyn, New York (Point B), and San Francisco (Freelink).

He currently lives with his wife and daughter in Brooklyn, New York.

Der 1968 in Kiel geborene Thomas Hoeffgen entdeckte seine Liebe zur Fotografie während eines Segeltörns um die Kanarischen Inseln, den er im Rahmen seines Zivildienstes mit straffälligen Jugendlichen unternahm. Er versuchte, die Situation etwas aufzulockern, indem er Porträts der Kinder machte, Momentaufnahmen schoss und gelegentlich auch die vorbeiziehende Landschaft einfing. So begann Hoeffgens spontaner bildlicher Umgang mit Bewegung – ein Ausblick auf seine spätere zuverlässige Gabe, flüchtige Momente in reduziertem, minimalistischem Stil festzuhalten.

Im Anschluss an seinen Zivildienst zog er im Alter von 20 Jahren nach Spanien, um der auf Mallorca arbeitenden Fotografin Elizabeth Schäufler zu assistieren. Noch bevor seine fotografische Ausbildung beendet war, buchten ihn renommierte Sportkunden wie Burton, Oxbow und O'Neill für Shootings. Er reiste um die ganze Welt, um Werbekampagnen zu fotografieren und Athleten auf Film zu bannen.

Diese frühen Arbeiten brachten Hoeffgen in Kontakt mit Mode- und Werbekunden, darunter G-Shock, Renault, O'Neill, Diesel, Maybelline, Escada, Laurel, Adidas, Microsoft, BMW, Swatch, Audi, Red Bull und Camel Active – und alle waren sie von seinem lockeren, unbekümmerten Stil, von seiner Energie und grafischen Klarheit angetan. Seine Arbeiten wurden unter anderem im *Stern,* im *SZ-Magazin,* in *Instyle, Glamour, Elle, Marie Claire, B&W Magazine, Anglomania, Wallpaper* und im *Outside Magazine* veröffentlicht. Ausstellungen seiner Fotografien fanden in Hamburg (Dormoolen), Düsseldorf (NRW-Forum), München (Goldberg Studio), Salem (Schloss Salem), Grasten (Atelier Corn Benniksgaard), Lissabon (Canon Gallery), Brooklyn, New York (Point B), und San Francisco (Freelink) statt.

Zurzeit lebt Thomas Hoeffgen mit Frau und Tochter in Brooklyn, New York.

This catalogue is published in conjunction with the exhibition
Thomas Hoeffgen: African Arenas

Auswärtiges Amt, Berlin
April 30 – June 2, 2010

Künstlerhaus, KunstKulturQuartier, Nürnberg
Presented by Deutsche Akademie für Fußball-Kultur
June 5 – July 18, 2010

and other venues

Editor: Nadine Barth
Copyediting: Melanie Newton (English), Simone Albiez (German)
Translations: Andrea Bargenda, Allison Plath-Moseley
Design: Julia Wagner, grafikanstalt, Hamburg
Typeface: Farnham
Paper: Galaxi Supermat, 170 g/m²
Production: Stefanie Langner, Hatje Cantz
Reproductions and printing: Dr. Cantz'sche Druckerei, Ostfildern
Binding: Conzella Verlagsbuchbinderei, Urban Meister GmbH,
Aschheim-Dornach

Published by
Hatje Cantz Verlag
Zeppelinstrasse 32
73760 Ostfildern
Germany
Tel. +49 711 4405-200
Fax +49 711 4405-220
www.hatjecantz.com

Hatje Cantz books are available internationally at selected book-
stores. For more information about our distribution partners, please
visit our homepage at www.hatjecantz.com.

You can find information on this exhibition and many others at
www.kq-daily.de

ISBN 978-3-7757-2668-9
Printed in Germany

Thomas Hoeffgen would like to thank the following persons and
companies for their support:
To all the football players in my pictures: I admire your extra-
ordinary passion.
Many thanks to Nadine Barth, Gilla Hof, Julia Wagner, and Ali
Gokay Sarioz for their invaluable help in putting together this book.
Thanks to my father Jochen Hoeffgen for driving me through Africa
and sharing the adventure.
Thank you to Alhaji Ahmed, Nikolaus Albrecht, Christian
Arnsperger, Michele August from 212 artists, Thomas Bergman,
William Chilufya, Civics FC, Claudia Delorme, Natacha and
Christian Devillers, the team from Donkey Communication GmbH,
Chris Häberlein, Caroline Hoeffgen, Humphrey from Thuso Security,
Nele Kahle, Christian Kandel, Inna Khavinson, Tine Kujawski,
Andreas Lebert, Stephan Lebert, Mathias Lindhuber, Mariane Linke,
Rick Matthews, Werner Mink, and Tim Mohr; to Eric Gukelberger,
Carl Wessel, and Julie Schaal from www.northsouthproductions.com;
and to Katharina Riess, Helmuth Scharnowski, Attila Sirman,
Sithole from Bad Boys Security, Robert Sperl, Elloise Van Rensburg,
Helmut Wahl, Volker Weschenfelder, and Harold Woetzel.
A very special thank you to Marco Lanowy, and:

ADenim **ALBERTO**
 Pants We Love

Cover photo: Lagos, Nigeria, 1999

Page 3: Sunset Stadium, Lusaka, Zambia, 2007